D0117351

NO LONGER PROPERTY OF
SEATTLE PUBLIC LIBRARY

POP ART
50 Works of Art You Should Know

Gary van Wyk

POP ART
50 WORKS OF ART YOU SHOULD KNOW

PRESTEL
Munich · London · New York

INTRODUCTION

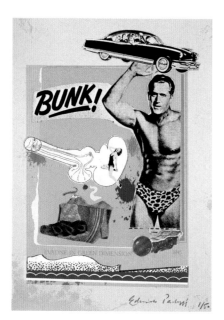

Eduardo Paolozzi, **Bunk**, 1972,
screenprint, private collection

In Eduardo Paolozzi's 1947 collage *I was a Rich Man's Plaything*, the word "Pop" pops from the barrel of a gun. The images collaged into this work were carried on the wings of war to Europe by American GIs in World War II. Inside its puffy, comic-book thought cloud, "Pop" literally hangs in the air between a pistol and a prostitute whose intimate confessions are emblazoned on a masthead with other trashy stories. Surrounding her are a B-52 bomber, a Coca-Cola ad, free-floating words, and a slice of cherry pie positioned between "sin" and her "moneymaker."

Paolozzi lived in Paris between 1947 and 1949, imbibed the heady mix of liberation, and collected such fragments of American popular culture for his collages. In 1952, Paolozzi assembled a coterie of fellow intellectuals into the Independent Group (IG), which met at the Institute of Contemporary Arts (ICA) in London. In Paolozzi's inaugural lecture there, entitled "Bunk," he showed them projected images edited from American magazines. The IG pondered the implications of mass media, mass marketing, and technology for modern life, and how these would shape the future.

Postwar Britain lacked pop and pizzazz. While Britain struggled to resurrect itself in the 1950s, the United States boomed, spurred by the increased industrial and manufacturing capacity that the war had brought, easy credit, and mass marketing. America's prosperity delivered such labor-saving devices as vacuum cleaners and washing machines, and such conveniences as refrigerators and shiny cars—inevitably advertised using attractive females—to the ideal modern home, which had a stay-at-home housewife and a TV set at its heart. Americans had work and wages, plenty of products to buy with their disposable income, "wheels," and leisure time to enjoy the movies, the beach, a drive, a Coke, or reading a comic or magazine: *TIME, Life, Fortune, LOOK, Mad, Esquire, Vogue, Playboy*. Such products and pastimes—many democratically accessible to rich and poor equally—exemplified America.

Advertising everywhere—especially on the color TV sets that entered American homes in the early sixties—enticed consumers

with promises of pleasure, of perfection, of paradise. What is readily available easily becomes popular, increased demand fuels production, and capital and credit make this world go round. "The medium is the message," said Marshall McLuhan—signaling that mass media affected society through the medium itself, apart from the content the medium delivered. The message of TV is to captivate captive consumers. The era of mass media and mass consumption had dawned, and life would never be the same. In popular culture, "the pure products of America go crazy" (in the words of American poet William Carlos Williams).

Ed Ruscha, **The Back of Hollywood**, 1977, oil on canvas, 22 x 80 in. (55.9 x 203.2 cm), Collection of Musée d'art contemporain de Lyon

Romance was in the air after World War II. The baby boomer generation was busy being conceived on the back seats of big cars and convertibles lavished with chrome and fins, and within the sanctity of marriages in suburban bedrooms. When those first postwar babies began to reach adulthood from 1963 and 1964 onward, they drove a decade of social revolution. *They* became the youthful audience that popular culture addressed, and its market. But the fifties America that the Baby Boomers grew up in was not all hunky dory. When WWII ended, the Cold War began, including the nuclear arms race and the space race. These fed the military-industrial complex, which President Dwight Eisenhower, a WWII general, presciently warned could grow to threaten American liberties, democratic processes, and peaceful methods and goals.

Pop artists on both sides of the Atlantic reflected the era's fascination with the space age and science-fiction visions of the future—as well as the nuclear threat. The USSR's testing of an atomic bomb and Mao Zedong's Communist victory in China in 1949, followed by China's support of North Korea in the Korean War from 1950 onward, spooked America. The House Un-American Activities Committee (HUAC), led by Republican senator Joseph McCarthy, accused thousands of Americans of being communists intent on toppling the state; it blacklisted and silenced intellectuals and artists, hounded many out of their jobs, and imprisoned others. This jingoistic rule of fear, abetted by J. Edgar Hoover's FBI, was not

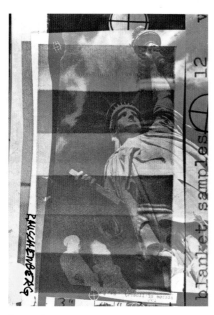

Robert Rauschenberg, **The Statue of Liberty**, lithograph on card, 28 x 19.9 in. (71 x 50.5 cm), Galleria d'Arte Moderna, Turin

unlike that imposed in totalitarian countries, and it made a mockery of the Bill of Rights and Americans' precious freedoms. This made it difficult and downright dangerous to talk about class or anything related to "socialism." That effectively bracketed out the examination of the "social" aspect of democracy, which Western European countries developed and refined in the postwar period. America had purely capitalist democracy. Germany, with the scar of the Berlin Wall at its heart, looked at "capitalist totalitarianism" skeptically.

America's officially sanctioned art in this period—even sponsored by the CIA as a Cold War propaganda weapon—was Abstract Expressionism, an art without figuration but filled with transcendental aspirations and heroic pretensions. It practitioners—known as the New York School—and particularly Jackson Pollock, the famous drip painter, were notorious in Manhattan as a crew of macho, womanizing, chest-thumping, hard-drinking, and sometimes brawling and bar-wrecking guys. The two main pioneers of Pop Art in America turned this on its head. Robert Rauschenberg and Jasper Johns, like the IG in London, opposed dominant strains of modernism.

By 1952, Rauschenberg was already breaking the constraints of the picture plane, making three-dimensional painted works, challenging the boundary between painting and sculpture. He incorporated found materials from the streets of New York, including bits of newspaper and cartoons, which brought the realities of daily life and popular culture into his works.

In 1953, Jasper Johns moved to New York, and ended up living in a Pearl Street apartment below Rauschenberg. They became artistic collaborators and were romantic partners for six years. In 1953, Rauschenberg asked the famous Abstract Expressionist painter Willem de Kooning to give him a dense drawing to erase. It took three weeks and fifteen erasers. When exhibited—with the title that Jasper Johns suggested, *Erased de Kooning*—its conceptual brilliance made Rauschenberg's name. Rauschenberg's appropriation was antiheroic, antiestablishment, and yet self-serving at the same time.

During the fifties Rauschenberg and Johns worked together—under the joint pseudonym of Matson Jones—as window dressers for the Fifth Avenue department store Bonwit Teller, under display director Gene Moore. Also contracted to work there in 1955 was Andy Warhol—the most successful illustrator in New York, but not yet famous or even fully recognized as an artist. Unlike the closeted lovers, Rauschenberg and Johns, whom Andy called the "staple-gun queens," Andrew Warhola's homosexuality was integral to the transgressive, antiestablishment art persona he transformed himself into: "Andy Warhol" engaged in art, rock and roll, advertising, filmmaking, publishing, and various sybaritic activities, as if in a continual existential performance or happening, constantly defying convention and criticism, while staying coolly composed. Ultimately, as Steve Cox says, Warhol became a "culture-changing force."

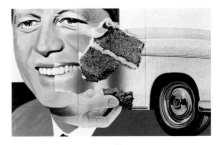

James Rosenquist, **Presidential Election: Kennedy**, 1960, screenprint, Musée national d'art moderne, Centre Georges Pompidou, Paris

Between 1952 and 1959, Warhol had seven small shows within the gay network, including Jean Cocteau-inspired line drawings of young men nude and in homoerotic situations. Andy enjoyed drawing the feet and penises of friends, notables, and nude models hired with his hefty earnings. Sometimes he sketched male models having sex, but remained solely a voyeur in these situations: "Sex is so abstract," he said. In later years, Polaroid photography and film would continue these voyeuristic interests.

Each of these three soon-to-be-famous Pop artists, together with James Rosenquist, debuted what would later be heralded as iconic Pop Art paintings in the windows of Bonwit Teller—a pairing of high art and retail shopping that seems pretty Pop in retrospect. Roy Lichtenstein also worked there.

Rauschenberg introduced Jasper Johns to his own dealer, Leo Castelli, who staged Johns's wildly successful solo debut show in January 1958—featured on the cover of that month's *Art News*. Alfred Barr, founding director of the Museum of Modern Art (MoMA), spent three hours at the show and bought the cover piece and two other works. Now, both artists were famous. American Pop had arrived, though not yet in name.

Rauschenberg's increasingly sculptural assemblages not only crossed into sculpture but into experimental performance. His *Minutiae* of 1954 was a set for choreographer Merce Cunningham and his creative and romantic partner, the avant-garde composer John Cage, who had befriended Marcel Duchamp in the forties. Rauschenberg and Johns's strategies owned much to Dada and Duchamp. From 1959 onwards, Rauschenberg and Johns, like Cage and Cunningham, counted Duchamp as part of their personal circle, continually made reference to Duchamp, and often worked directly with him.

During his art school years, Warhol also identified with Duchamp. Warhol met Cage at the age of fifteen, was familiar with his work and its Dada strategies, and attended performances in and around New York connected to this circle during the sixties. Warhol admired the work of "Neo Dadaist" or "New Realist" artists, and purchased a drawing by Jasper Johns, who recalled the event and said, "Everyone knew everyone else in the New York art world." In 1961 alone, Warhol bought three Johns lithographs, an Ellsworth Kelly watercolor, a Ray Johnson collage, and a painted shirt by Jim Dine.

Warhol's breakthrough was just around the corner. His Los Angeles solo debut of *Campbell's Soup Cans* was neither a critical nor commercial success, but his 1962 New York solo show at Stable Gallery, which included *Marilyn Diptych*, was a sellout and a sensation. As Warhol wrote in his memoir *POPism*, he had finally grasped that the "new realism" meant painting: "Comics, picnic tables, men's trousers, celebrities, shower curtains, refrigerators, Coke bottles: all the great modern things the Abstract Expressionists tried so hard not to notice at all." The rest is history. Today, Warhol is recognized as the leading figure of Pop Art, rivaling Picasso in his productivity and the range of media in which he made groundbreaking contributions—painting, printmaking, film, music production, multimedia rock-concert staging, and graphic design. To this must be added the cultural force of Andrew Warhola's invented persona: Andy Warhol, who performed a provocative being-in-the-world behind his inscru-

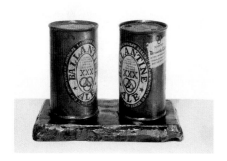

Jasper Johns, **Painted Bronze (Ale Cans)**, 1964, cast 2/2, painted bronze, 5.4 x 7.9 x 4.3 in. (13.7 x 20 x 11 cm), private collection

table mask. Warhol's constant pose of disavowal—including his antiheroic denials of meaning, intention, and motive—is, perhaps, his most Dada: "Gee, I dunno." Duchamp gave up art for chess, and Andy played the queen. And became a hero, like Duchamp.

The flowering of Pop Art and its enduring appeal and relevance—apart from its astronomic current market value—can only be fully appreciated against the backdrop of the sixties and early seventies, and the clues to the character of those decades lie in the postwar era.

In World War II, soldiers of all races had fought and died side by side throughout the world. That added momentum to struggles for racial equality in the US and elsewhere, and against colonialism, particularly in Africa but also in Asia. France's attempt to reassert colonial control over Vietnam after WWII laid the foundations for America's disastrous Cold War entanglement there. America also ended up opposing African liberation struggles—notably in the Congo and South Africa—because it feared socialist influence. In 1948 President Truman ordered equal treatment in the US armed services. In 1954, the Supreme Court of the United States ruled school segregation unconstitutional, impelling a decade of struggle for equal rights that culminated in President Johnson's signature of the Civil Rights Act of 1964, which outlawed discrimination. A racist backlash ensued. The assassination of Dr. Martin Luther King, Jr. on April 4, 1968, led to protests in more than a hundred American cities. In Chicago, thousands were arrested and several people killed during four days of riots. Elements of the Black Power movement became radicalized and moved away from the nonviolent strategy advocated by King. These historical events are represented in some Pop Art works.

Sex and drugs and rock and roll were vital elements of the sixties and popular culture. The contraceptive pill promoted the sexual revolution by bracketing out the risk of conception. Young people's exploration of sexuality outside of the compact of marriage challenged the status quo. So did the use of drugs, especially marijuana

and LSD, passionately advocated by Timothy Leary and Ken Kesey beginning in 1960 and widely used by the mid-sixties. LSD was legal in the US until 1966. Millions of people discovered that drugs opened the "doors of perception"—as British writer Aldous Huxley had titled his influential 1954 book on personal drug experimentation. This fit the zeitgeist of experimentation, exploration, self-awareness, and new modes of expression—and of being.

The influence of drugs on Pop Art—and other art during the fifties through the seventies—should not be underestimated. Under the influence of drugs, even the most banal thing can become profoundly thought-provoking, moving, amusing, even mind-blowing. A row of soup cans could arrest one in a supermarket, or a gallery. Drugs can also inspire far-out ideas.

The struggle for sexual liberation was a leitmotif of the latter twentieth century. This entailed not only striving for equality between men and women, but also for gay, lesbian, bisexual, and transgender (GLBT) rights. Women, who had taken on new roles during World War II, felt more empowered and liberated, and they wanted more; but it was a sexist world. This was felt in art schools, too—and it is key to explaining why so few women Pop artists have been recognized, until recently. When Jann Haworth applied to the Slade School of Art in London in the early sixties, she was told "the girls were there to keep the boys happy." Not all the boys were interested in girls, though, or vice versa: the queer question was part of the sexual revolution—and gay men, in particular, were key to Pop's "rebellion" against macho modernism. The Equal Rights Amendment of 1972, intended to guarantee women's equality in the US, was never ratified.

A New York Police Department raid on the gay bar the Stonewall Inn in Greenwich Village on June 28, 1969, sparked violent protests that launched the gay liberation movement in the US. The first anniversary of Stonewall was marked by the first Gay Pride marches in New York, Los Angeles, and Chicago.

Europe, too, was rocked by upheavals in the late sixties. In March

1968, Polish students and intellectuals took to the streets to oppose official censorship. The Polish government retaliated with an anti-Semitic campaign and forced the emigration of 15,000 Polish Jews. The Prague Spring of 1968 challenged Soviet totalitarianism as a betrayal of the ideals of socialism. It provoked the Soviet Union to invade Czechoslovakia to crush resistance there and elsewhere behind the Iron Curtain. In Paris in May 1968, students took to the streets. The labor movement soon joined them. They nearly toppled the government, demonstrating that, without reform toward the kind of civil society that the youth envisaged and demanded, revolution might ensue.

Chicago hosted the Democratic National Convention in August 1968. Mayor Richard J. Daley supported President Johnson—whose escalation of the Vietnam War was increasingly unpopular. Opposing Johnson for the Democratic nomination was George McGovern, who opposed the war—as had another promising opposing candidate for the Democratic nomination, Robert F. Kennedy, assassinated on June 5, 1968.

To coincide with Mayor Daley's "Convention of Death," the Yippies (Youth International Party) planned a six-day "Festival of Love." Founded on the last day of 1967, the Yippies represented the politici-zation of the hippie movement. Cofounder Paul Krassner explained, "We needed a name to signify the radicalization of hippies, and I came up with Yippie as a label for ... an organic coalition of psyche-delic hippies and political activists. In the process of cross-fertiliza-tion at antiwar demonstrations, we had come to share an awareness that there was a linear connection between putting kids in prison for smoking pot in this country and burning them to death with napalm on the other side of the planet."

Yippies did not seek a role inside the system; they wanted a radically altered state that also permitted drug-induced altered states of consciousness. With typical theatricality, Yippies threatened to put LSD in Chicago's water supply and make love on the beaches. But their primary demand, clear and serious, an immediate end to

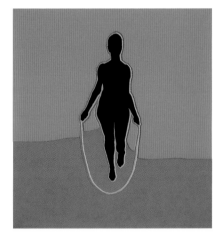

Idelle Weber, **Jump Rope Lady**, 1966, collage with color-aid paper and tempera, 12.6 x 18 in. (32.1 x 45.7 cm)

Christa Dichgans, **Häufung mit Batman**, 1967,
synthetic resin on canvas, 21.7 x 27.6 in.
(55 x 70 cm), Galerie Daniel Blau, Munich

war in Vietnam, was supported by the National Mobilization Commit-
tee to End the War in Vietnam (MOBE), a coalition of 500 antiwar
groups, and 10,000 protestors who arrived for their Festival of Love.

Mayor Daley's police force and Illinois National Guardsmen,
totaling 23,000, gassed, arrested, and beat up protestors—and
even the respected journalist Dan Rather—in the full glare of the
TV cameras. The protestors shouted, "The whole world is watching."
They understood the power of the media, and knew that an era
of virtually global TV audiences had dawned. Not only news was
shared, but ideas: students worldwide joined movements for
peace—opposing the Vietnam War and nuclear arms—for civil rights
and racial equality, for feminism, and for environmental protection.

Though these struggles for social reform differed, they shared a
youth-driven anti-authoritarianism that changed the twentieth
century and how much of the world views the ideals of civil society
today. In America, these struggles—for equal rights for women and
minorities and for equal treatment before the law—are ongoing.

In recent years, the stereotypical view of Pop Art as the exclusive
preserve of male American artists—or at best Anglo-American
artists—has been challenged. The exhibition Seductive Subversion:
Women Pop Artists, 1958–1968, curated by Sid Sachs (2010), shone
fresh light on the careers of women Pop artists who had been
overlooked, as did Power Up: Female Pop Art, produced by the
Kunsthalle Wien. Other countries apart from American and England
also had Pop artists—or artists who participated in Pop, who
traveled in parallel, or who were empowered by it. These recent
perspectives have influenced the selection for this book of fifty
works of Pop Art you should know.

Additional Reading

Carlos Basualdo and Erica F. Battle, eds. *Dancing Around the Bride: Cage, Cunningham, Rauschenberg, and Duchamp*. Exh. cat. Philadelphia Museum of Art; Barbican Centre for Arts and Conferences. Philadelphia and London, 2012.

Steve Cox. "Andy Warhol: Killing Papa." Steve Cox website, n.d. http://www.stevecox.com.au/ANDY-WARHOL-KILLING-PAPA.

Stephen Koch. *Stargazer: The Life, World, and Films of Andy Warhol*. New York, 1991.

Rebecca Lowery. "The Warhol Effect: A Timeline." In *Regarding Warhol: Sixty Artists, Fifty Years*. Exh. cat. Metropolitan Museum of Art. New York and New Haven, 2012, pp. 250–79.

David McCarthy. "Andy Warhol's *Silver Elvises*: Meaning through Context at the Ferus Gallery in 1963." *The Art Bulletin* 88, no. 2 (June 2006).

Tilman Osterwold. *Pop Art*. Cologne, 2012.

John Russell and Suzi Bablik. *Pop Art Redefined*. Exh. cat. Hayward Gallery. London and New York, 1969.

Sid Sachs and Kalliopi Minioudaki, eds. *Seductive Subversion: Women Pop Artists, 1958–1968*. Exh. cat. Rosenwald-Wolf Gallery, Philadelphia. New York and London, 2010.

Jerry Salz. "The Met's 'Regarding Warhol' Has Nothing to Say." *New York Magazine*, September 24, 2012.

Angela Stief, ed. *Power Up: Female Pop Art*. Exh. cat. Kunsthalle Wien, Vienna. Cologne, 2010.

Andy Warhol and Pat Hackett. *POPism: The Warhol '60s*. New York, 1980.

Warholstars.org, an ongoing research and archival project by Gary Comenas, http://www.warholstars.org/about.html.

50 WORKS OF ART

MARCEL DUCHAMP
Fountain

1917

In 2004, *Fountain* was voted the most influential work of the twentieth century by a panel of five hundred art specialists. Without Duchamp's readymades—such found objects as this urinal, which he designated as art from 1913 onwards—Pop Art never would have existed. This might seem surprising, because Pop Art appears to trumpet surface over substance, but beneath Pop's glossiest manifestations lie strategic moves that Duchamp made first.

Duchamp's readymades undermined the elitism of "high" art by insisting that whatever the artist said was art became art. Art could be anything, even the urinal that he titled *Fountain*, tilted ninety degrees, and submitted to a prestigious New York art show in 1917—for which he was a judge—under the pseudonym of R. Mutt. Pronounced in German, this name sounds like *armut*, meaning poverty—an ironic contrast to the status and wealth of the show's patrons. Duchamp said the initial "R" stood for Richard, which, in French slang, means "moneybags."

Rejected by the hanging committee, *Fountain* found its way to Stieglitz's photography studio. Duchamp publically acknowledged the work, and since he was already a famous figure, *Fountain* was then published worldwide, becoming globally famous. However, Duchamp, in a letter to his sister, credited an unnamed female collaborator with the whole idea, denying his authorship.

Fountain exposed and displaced both the art world's structures of taste and patronage and its heroics of authorship and originality. Duchamp substituted low—even vulgar and funny—for high. This set the tone for three important strategies of Pop Art: the appropriation of the commonplace; the Dada strategy of reifying ordinary objects as art by fiat of artistic intention; and the use of impersonal methods of production that bypassed the artist's hand and personality to undercut the cult of genius. The strategies of New York Pop Art progenitors Rauschenberg and Johns owned much to the Dada art movement and Duchamp in particular. Warhol, too, during his art school years, identified with Duchamp. Perhaps the first exhibition from which Warhol was rejected was when he submitted a "self-portrait" of Duchamp picking his nose to a senior exhibition at Carnegie Tech—the only juror to defend the work was George Grosz, who had personal links to Dada.

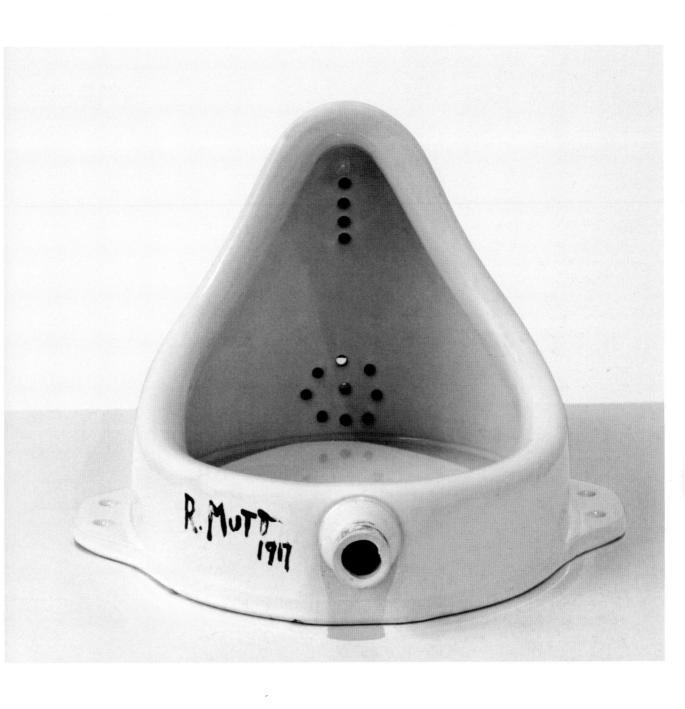

Marcel Duchamp, **Fountain**, 1917,
porcelain urinal, 24 x 18.9 x 14.1 in. (61 x 48 x 36 cm),
Moderna Museet, Stockholm

EDUARDO PAOLOZZI
I was a Rich Man's Plaything

Eduardo Paolozzi pioneered Pop Art in Britain—but in 1947, when Paolozzi pasted the sound-word "POP!" into this collage, the concept of Pop Art did not exist yet. In its combination of several elements that would later be recognized as key concerns in Pop Art—American imagery, advertising copy, cartoon conventions, consumer items, vulgar popular products, and sensational sexuality—this collage is hailed as the first work of Pop Art.

In August 1952, Paolozzi was a founding member of the Independent Group (IG), which focused British artists, designers, and intellectuals on the implications of popular culture and on the power that mass media and mass marketing have to shape aspirations and desire. The IG met informally at the Institute of Contemporary Arts (ICA) in London. Founding members included critics Toni del Renzio and Reyner Banham, architects Alison and Peter Smithson, Richard Hamilton, and other artists and designers. Critic Lawrence Alloway and graphic designer John McHale—who both claimed to have first used the term Pop Art—and musician Frank Cordell and painter Magda Cordell, his wife, joined in 1953. Their

interdisciplinary topics of discussion included the mass-media theories of Marshall McLuhan, advertising, new artistic techniques, cinema, comics, trash literature, pop music, fashion, helicopter and car design, machine aesthetics, nuclear biology, and cybernetics.

In 1953, Paolozzi co-curated, with the Smithsons and others, the ICA exhibition *Parallel of Life and Art*, which focused on mass media and science and technology and their relevance to art. X-rays and enlarged reproductions of art and illustrations from magazines, encyclopedias, and science publications covered the walls and ceiling at odd angles, creating a disorienting environment: a metaphor of contemporary life.

"POP!" read with "CHERRY" in this collage evokes the slang term for "to deflower"—"to pop the cherry"—and the Coke bottle and pistol are phallic pointers. The pistol that Paolozzi pasted in front of the woman's face implies violence; the "POP!" that shoots out signals death—it is the pop of the balloon deflating. In this Paolozzi image, men master machines, they are heroes flying high; women are low sinners, sirens of the street, playthings.

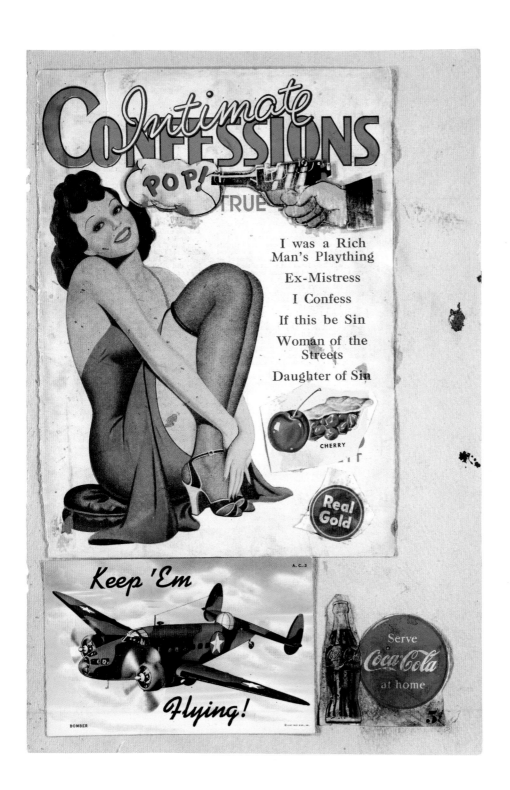

Eduardo Paolozzi, **I was a Rich Man's Plaything**, 1947,
printed papers on card, 14.1 x 9.3 in. (35.9 x 23.8 cm), Tate, London

ROBERT RAUSCHENBERG
Minutiae

1954

Robert Rauschenberg's *Minutiae* is a mixed-media work, built on a wooden structure, that crosses the boundary between painting and sculpture: it steps away from the wall and into life. It incorporates ordinary found objects—pieces of balustrade and lace, a plastic-framed mirror, images—and such everyday materials as string and newspaper. Jasper Johns later named this type of work a "combine." Choreographer Merce Cunningham commissioned *Minutiae* as a stage prop for a dance set to music by his partner John Cage. *Minutiae* is fully three-dimensional, with two rigid panels and a section of fabric curtain. Dancers can pass through its spaces, and it invites the viewer to do the same. The human scale of this work differentiates *Minutiae* from low-relief collages by earlier artists.

The mirror in the front panel is fixed, yet captures—albeit fleetingly—and reflects every change in the space; it registers the viewer's presence, then loses it. It incorporates time into the work, and invites the viewer to reflect on the fleeting nature of time—and images.

Rauschenberg met Cage and Cunningham during his first solo exhibition at Betty Parsons Gallery in New York in 1951. The trio spent the summer of 1952 at Black Mountain College, North Carolina, developed strong friendships, and completed the first of several collaborations, which always incorporated elements of chance. When Rauschenberg met Johns, he too joined their circle. Rauschenberg was also associated with New York avant-garde performers in the Judson Dance Theater, and was a dancer and choreographer. He was resident advisor for the Merce Cunningham Dance Company (MCDC) from 1954 through the 1964 world tour—until his statement that the MCDC was his "biggest canvas" offended Cage. Johns succeeded Rauschenberg as artistic director from 1967 to 1980.

Cunningham recalled in an interview that when the MCDC took *Minutiae* on tour, Rauschenberg packed it into a box lashed to the top of their VW bus, hoping it wouldn't rain. Many years later, when Rauschenberg's works had become valuable, Cunningham was performing in Paris and a man told him that he had purchased *Minutiae* in Zurich and transported it to Paris in a padded, air-conditioned van. The irony sent Cunningham into fits of laughter. "My God," he gasped. "Lucky it didn't rain!"

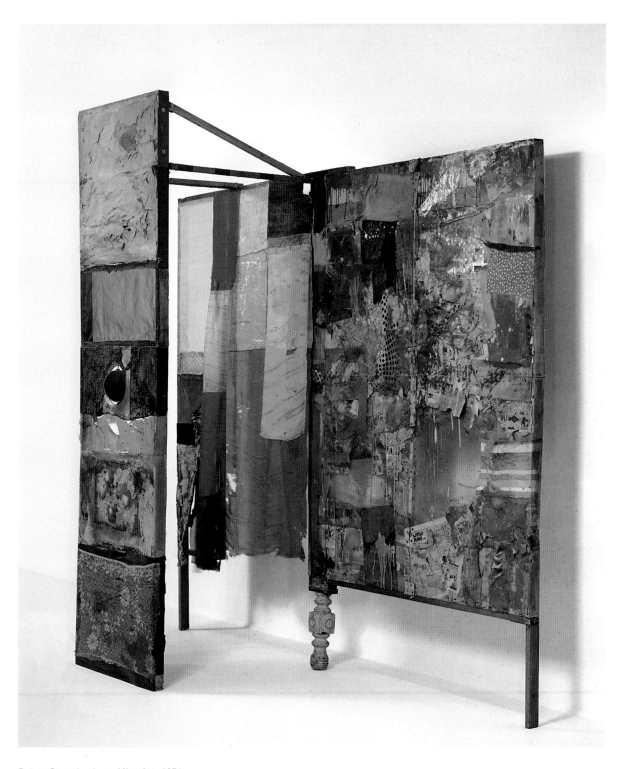

Robert Rauschenberg, **Minutiae**, 1954,
combine: oil, paper, newspaper, wood, metal, plastic,
with mirror on braided wire, on wood structure, 84.5 x 81 x 30.5 in.
(214.6 x 205.7 x 77.4 cm), private collection

4

RICHARD HAMILTON
Just what is it that makes the modern home
so different, so appealing?

1956

This iconic work of Pop Art featured in the 1956 exhibition *This is Tomorrow* at Whitechapel Gallery in London, and echoes some of the ideas in Eduardo Paolozzi's 1947 collage *I was a Rich Man's Plaything* (pp.26/27). Here incongruous images in a domestic setting unsettle the mass media's image of the ideal home, regulated by a virtuous housewife and the prompts of the TV set.

"POP" seems to balloon from the bodybuilder's briefs. The sucker top aligns with a can of meat, while its stick points to the vacuum's extra-long pipe. In American slang, "tootsie" means "young girl," a girlie reference that undermines the macho-man. He looks at the viewer, rather than the reclining woman, naked but for her lampshade headgear, which references a form of haute-couture hat in the 1950s. She looks at the viewer, too. Their sexual poses deny the ideal of the stable, married "mom and pop" around which the "modern home" is constructed.

Both the setting and the title of the collage come from an Armstrong Floors ad in the June 15, 1954 *Ladies Home Journal*, which also contained the ad of the Hoover Constellation working the staircase. The bodybuilder is Mr. L. A. 1954, "Zabo" Koszewski, cut from

Tomorrow's Man magazine (September 1954). The artist and soft-porn model Jo Baer recognized herself as the erotically posed woman. The ceiling is an image of earth that John McHale cut from *Life Magazine* (September 1955). The black-and-white rug depicts sunbathers packed on a beach. A blown-up *Romance* comic hangs on the wall—presaging the work of Roy Lichtenstein—alongside a stuffy high-art portrait in its paste frame.

In 1956, Hamilton understood "pop" to mean "popular." In a 1957 letter to Alison and Peter Smithson, he clarified, "Pop Art is: Popular (designed for a mass audience), Transient (short-term solution), Expendable (easily forgotten), Low-cost, Mass-produced, Young (aimed at youth), Witty, Sexy, Gimmicky, Glamorous, Big Business." Hamilton states, "At the time the letter was written there was no such thing as 'Pop Art' as we now know it. The use of the term here refers solely to art manufactured for a mass audience." Hamilton neither advocated these qualities in his own work, nor did what later became known as British Pop Art fit these criteria. Hailed as a "father" of Pop Art, Hamilton disavowed the accolade. His stance toward popular culture was critical and philosophical.

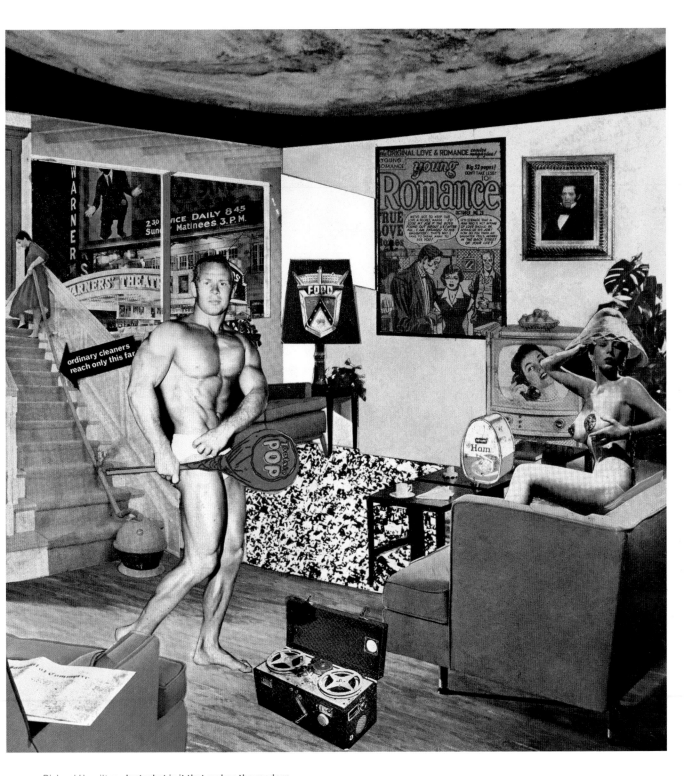

Richard Hamilton, **Just what is it that makes the modern home so different, so appealing?**, 1956, collage on paper, 10.2 x 9.8 in. (26 x 25 cm), Zundel Collection, Kunsthalle, Tübingen

JASPER JOHNS
Flag on Orange Field

Johns was inspired to begin his iconic *American Flag* series by a dream in which he saw himself painting one. This changed his life—and the course of Pop Art.

In 1954, Jasper Johns destroyed all his prior art and resolved to leach the personal from his practice, stating, "I don't want my work to be an exposure of my feelings." He selected as subjects "things the mind already knows," as he put it—flags, targets, numerals, and maps of the US. Though Johns stripped his personality from his work, his painterly surfaces referenced their creator. His images of such simple signs as flags pose logic puzzles of identity: if one paints a flag, is it a flag or a painting; does it stand for the United States of America—a country whose unity is denied by its multiplicity? And does the answer shift when the flag/painting inaccurately represents the number of states—in this work, there are only forty-eight stars—and becomes a modern sign of the nation in an earlier state?

Such philosophical and perceptual questions are deeper concerns in Johns's work. Johns was influenced by the philosopher Ludwig Wittgenstein's writings on logic and language, which separated words from their meanings or contexts. The act of isolating the sign from its context or meaning and recontextualizing it as art was a key strategy in Pop Art. Critics recognized that this approach had many links with earlier Dada practices, and labeled works of Johns, Rauschenberg, and other Pop Art pioneers exhibited in the 1950s as "Neo-Dada."

Flag on Orange debuted in 1957 as a window display in the now defunct department store Bonwit Teller. The display director there, Gene Moore, "curated" the early appearance of many future Pop masterpieces. The guy had an eye.

A popular American synonym for an iris flower is a flag. One could therefore interpret John's title to mean "iris on orange field"—which then invites recall of other artists' works that represent real flowering fields, such as Claude Monet's famous *Field of Red Poppies*, as critic Barbara Rose has suggested. The orange frame around the flag stands in for a field, and the flag stands in for a flower: things are not what they seem. Such visual, linguistic, and language games pepper and enrich Johns's work. The surface, painted in encaustic, undulates like a field, too.

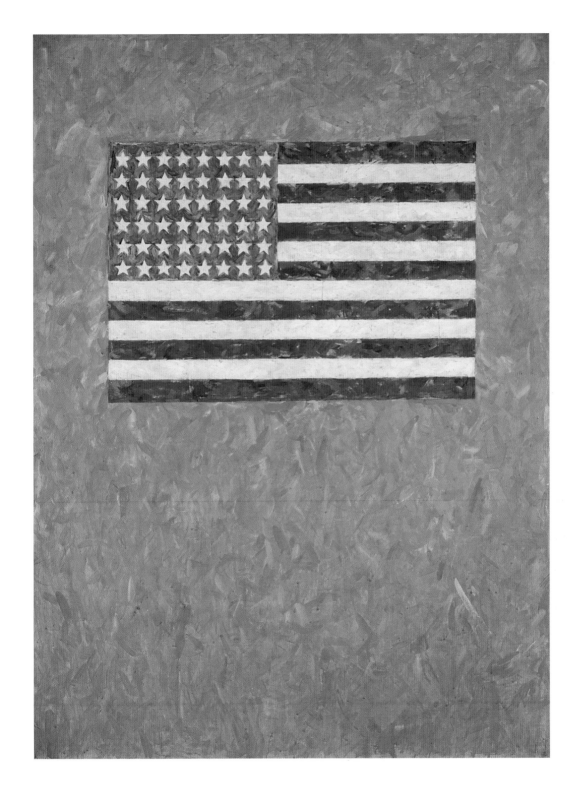

Jasper Johns, **Flag on Orange Field**, 1957,
encaustic on canvas, 65.7 x 48.1 in. (167 x 124 cm),
Museum Ludwig, Ludwig Donation, Cologne

JASPER JOHNS
Painted Bronze (Ale Cans)

Painted Bronze (Ale Cans) is an inverse of a readymade, yet poses similar questions of high and low, art and life, illusion and reality. Instead of a mass-produced object recontextualized as a work of art, Johns simulated mass-produced objects in the pricey bronze reserved for such high-art sculptures as equestrian emperors—and Picasso's 1914 painted bronze, *Glass of Absinthe*, an important precedent. Like other commodities iconized in Pop Art, Ballantine beer was enjoyed equally by the common consumer and the celebrities, including Marilyn Monroe, who endorsed it: Joe DiMaggio, John Steinbeck, Ernest Hemingway, Rocky Marciano, and Frank Sinatra. It was the first beer consumers could carry home as a six-pack.

Jasper Johns said that a remark about his gallerist, Leo Castelli, inspired the sculpture: "Somebody told me that Bill de Kooning said that you could give that son-of-a-bitch two beer cans and he could sell them. I thought, what a wonderful idea for a sculpture." Johns produced the first of two casts in 1960, which Castelli exhibited in 1961—and duly sold.

This sculpture plays with ambiguities of identity. It is a single sculpture, yet looks like two beer cans pressed into a base that also bears Johns's thumb-print—a bodily trace. The bronze cylinders and painted logos echo—yet differ from—mass-produced Ballantine cans, although the work was "editioned": Johns cast and painted #2/2 in 1964, which he kept. One can is depicted opened, and is hollow and light; the other is closed, solid, heavy. One must separate the twinned cans, lift them off their base, mimicking the motion of a drinker, to reveal their differences. Such philosophical concerns virtually touch on questions of human partners. Johns and Rauschenberg's relationship was coming to an end. Only one logo contains the word "Florida," the tropical state whose Latin name means "flowery," and evokes the word "florid"—implying flushed (often a side effect of alcohol and sex) or excessively complicated. Rauschenberg, a heavy drinker, later moved to Captiva Island, Florida. "XXX" is a sign of brewing purity—and pornography. Such subtle plays, often personal and allegorical, delighted Duchamp and other Dadaists. Johns certainly found *Painted Bronze (Ale Cans)* endlessly fascinating: he reworked the subject in different media and guises for years.

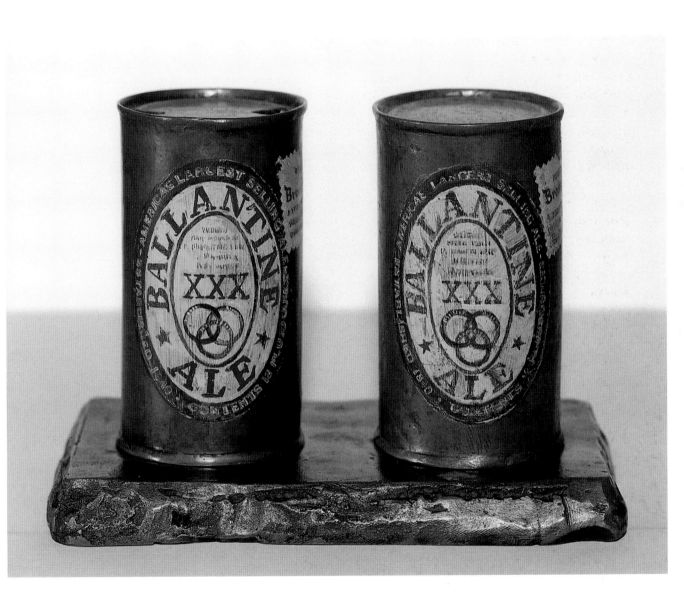

Jasper Johns, **Painted Bronze (Ale Cans)**, 1960,
oil on bronze, 5.5 x 7.9 x 4.7 in. (14 x 20.3 x 12 cm),
Museum Ludwig, Ludwig Donation, Cologne

JASPER JOHNS
Map

1961

During the 1960s, Jasper Johns—like Eduardo Paolozzi and other artists—was profoundly affected by the philosopher Ludwig Wittgenstein's logic and his writings on language, which distinguished the sign from what it referred to. The extrication and elevation of the sign was a foundation of Jasper Johns's pioneering work and became an enduring feature of Pop Art.

Johns emphasized the concrete in his work, and selected stock subjects: the flag and map of the United States, targets, and numbers. Though apparently straightforward, these subjects can be read as posing logic puzzles of identity.

The US, for example, rendered via its flag or map, is both a singular entity and composed of multiple fractious states. One is many. Also, the map or flag excised from its familiar contexts of civic authority and classroom and repositioned on a gallery wall becomes an entirely different thing. The sign floats free.

Rauschenberg had introduced Jasper Johns to his own dealer, Leo Castelli, who immediately appreciated the influence of Duchamp in Johns's work and staged his wildly successful debut solo show in January 1958. Johns's

work was featured on the cover of that month's *ArtNews*. Alfred Barr, the Museum of Modern Art's founding director, spent three hours at the exhibition, and bought the cover piece and two other works. Now, both artists were famous. American Pop had arrived, though not yet in name.

In 1960, Rauschenberg gave Johns a cheaply reproduced classroom map of the United States. Johns understood the gesture to mean he should add this subject to his repertoire. He first over-painted the found object, and then enlarged it as a painting, allowing many paint drips to remain. These reflect the operation of chance within the work, but also the artist's control over the choice to leave or remove the drips. This underscores the process of painting, rather than the realization of a preconceived idea. The labels of the states are applied arbitrarily—Colorado appears several times. What were different states become the same. Territories are distorted; their boundaries blur; they become deterritorialized. What was one thing becomes another—and Jasper Johns's finished map is quite unlike the found object he started from.

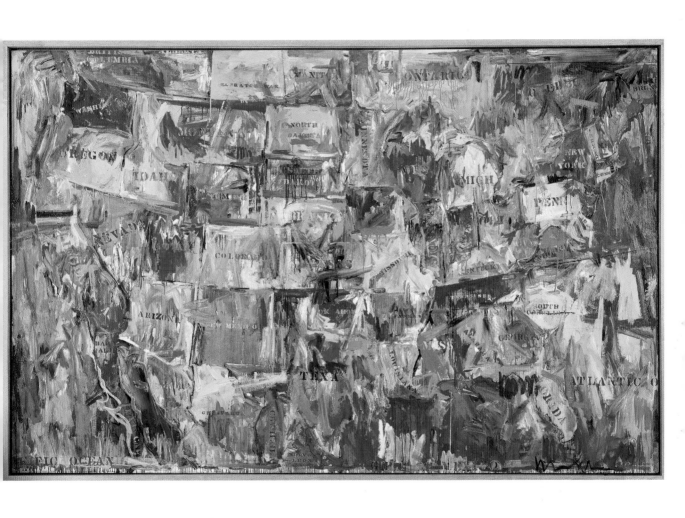

Jasper Johns, **Map**, 1961,
oil on canvas, 78 x 123.9 in. (198.2 x 314.7 cm),
The Museum of Modern Art, New York

CLAES OLDENBURG
Floor Burger (Giant Hamburger)

1962

Claes Oldenburg's vision of sculpture was revolutionary. From 1959 onward, he rendered subjects from the streets of his poor Lower East Side neighborhood and from everyday life. His novel media included trash—cardboard, newspaper, and the burlap sacks then used for bagging garbage. His sculptures hung on the wall or from the ceiling or stood directly on the floor. Gradually introducing color, he restricted his palette to seven bright colors of sloppily applied enamel paint, creating surfaces both gritty and commercial looking.

In December 1961, Oldenburg created one of the first art installations. He opened his studio on weekends as *The Store*, selling painted plaster sculptures of food and clothing—some simulacra, some with hallucinatory scale distortions—with price tags mimicking American retailers' prices ending in "-9" cents. This highlighted his art as a commodity, no less than the everyday objects he chose as valid subjects, and contrasted with the gallery setting where he'd shown similar works earlier that year. Some sculptures sat on the crockery or display hardware used in real stores and delis, blending the real and the art object.

The Store was a setting for happenings attended by such art-world personalities as Marcel Duchamp and Andy Warhol. Oldenburg's performers included Lucas Samaras, Red Grooms, Jim Dine, and Patty Mucha, who sewed props from burlap and other materials that inspired giant soft sculptures of edibles, of which *Giant Hamburger* is best known. Stuffed with foam rubber and boxes, this work invites viewers to interact with it—and make something happen. Patty and Claus made love on the meat, between the buns.

The Art Gallery of Ontario's purchase of *Giant Hamburger* in 1967 caused art students to protest outside with a giant sculpture of a ketchup bottle, of which Oldenburg said, "They should have made it soft." Oldenburg's more enduring artistic concern was not soft sculpture but gigantism. His monumental sculptures of everyday objects, made with Coosje Van Bruggen since the seventies, are popular for their wit, often accentuated by their context. *Batcolumn* (1977) is a towering baseball bat erected among Chicago's skyscrapers. *Dropped Cone* (2001) projects from the top corner of a Cologne mall, as if an ice cream had been discarded by a god on high.

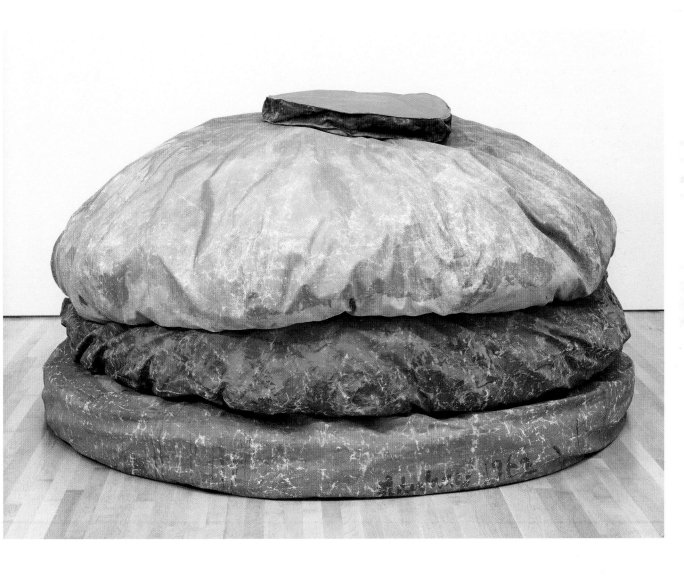

Claes Oldenburg, **Floor Burger (Giant Hamburger)**, 1962,
acrylic on canvas filled with foam rubber and cardboard boxes,
52 x 84 in. (132.1 x 213.4 cm), Art Gallery of Ontario, Toronto

ED RUSCHA
Large Trademark with Eight Spotlights

Ed Ruscha explained of *Large Trademark with Eight Spotlights* that as a kid he had loved the cinematic device of a train that comes from nowhere and zooms into shot from lower right to upper left. He found it cosmic and sweet; he charted it out on canvas; and used that compositional format not only in this work but also in several others.

Ruscha completed *Large Trademark with Eight Spotlights* in 1961, one year after graduating from college. It remains a signature work, signaling his interest in commercial graphics and the intrusive presence of commercial media in daily life—fortuitous for Ruscha, because this movie-inspired work gained him early notice in Pop Art circles. He designed the poster for, and was included in, the influential exhibition *New Painting of Common Objects* at the Pasadena Art Museum in 1962, curated by Walter Hopps, who organized Marcel Duchamp's retrospective there and introduced Ruscha to Duchamp. Ruscha had his solo debut at Ferus Gallery in Los Angeles—after Andy Warhol—in 1963. Soon afterward, he produced three equally well-known paintings of buildings on fire—*Norm's, La Cienega, on Fire* (1964), *Burning Gas Station* (1965–66), and the truly incendiary *Los Angeles County Museum of Art on Fire* (1965–68).

Much of Ruscha's work combines the cityscape of L. A. with existing vernacular language to communicate a particular urban experience, hold up the mirror to the banality of urban life, and give order to the barrage of mass media-fed images and information that confronts us daily. Nothing epitomizes L. A. more than Hollywood, and *Large Trademark with Eight Spotlights* lionizes the movie industry. The corporate logo of the studio has become the subject of a Cinema-Scope-format painting, just as the power of the studio—and of mass media in general—has come to loom large in everyday life, to dominate our experience.

Ruscha's career and output have been prodigious, in many media. His conceptual photography works, such as *Twenty-six Gasoline Stations* (pp. 46/47), are vital and influential contributions. During the seventies, Ruscha spelled out words in such unconventional media as gunpowder, blood, coffee, caviar, and cherry pie, among many others. He represented the US at the 1970 Venice Biennale with *Chocolate Room*, covering the gallery with 360 chocolate shingles.

Ed Ruscha, **Large Trademark with Eight Spotlights**, 1962,
oil on canvas, 66.7 x 133.2 in. (169.5 x 338.5 cm),
The Eli and Edythe L. Broad Collection, Los Angeles

ROY LICHTENSTEIN
Masterpiece

Lichtenstein's 1962 solo debut at Leo Castelli Gallery sold out before opening night. It included *Masterpiece*, which wittily references the jostling for recognition among the New York Pop artists in the early sixties who strove to emerge from what was being labeled as "Neo-Dada" or "New Realism."

Hitting on something new could be key. Rauschenberg had begun to integrate found comic strips into such painted works as *Minutiae* in the fifties. In 1960, Andy Warhol painted the macho characters of his boyhood fantasies, including Dick Tracey and Popeye, and superheroes Batman and Superman, with speech bubbles. These were displayed in the storefront of Bonwit Teller in spring 1961.

One of Lichtenstein's young sons pointed to an illustration of Mickey Mouse and Donald Duck fishing in a children's book and challenged his father to paint something similar. Lichtenstein's resulting *Look Mickey* (1961) added a speech bubble to the illustration, flattened and reduced the color, and used cartoon-like half-tone dots and dashes for the skin tones, applied with a dog-grooming brush. Lichtenstein produced several related works in 1961,

drawn from commercial imagery, such as gum wrappers.

Allan Kaprow, a colleague at Rutgers University in New Jersey, endorsed Lichtenstein's integration of images drawn from everyday life. Another friend, Lettie Eisenhauer, brought Ileana Castelli, whose father was the capital behind Leo Castelli Gallery, to see Lichtenstein's work. Ileana purchased paintings, and the gallery signed Lichtenstein in October 1961. After Ileana married the European gallerist Michael Sonnabend, they promoted Lichtenstein and other Pop Art in Europe.

Warhol was frustrated to learn that Castelli's had cartoon paintings by Lichtenstein; he suspected Lichtenstein had seen his *Superman* and *Saturday's Popeye* at Bonwit Teller's, where Lichtenstein had been a sign painter. But Warhol recognized the superiority of Lichtenstein's technique—the blown-up, flat-colored Ben-Day dots became his instantly recognizable Pop signature. He spent his career refining his technique and his formal manipulation of subjects that included landscapes and other artists' masterpieces. His later works lacked the novel impact of his paintings of the early sixties, such as *Masterpiece*.

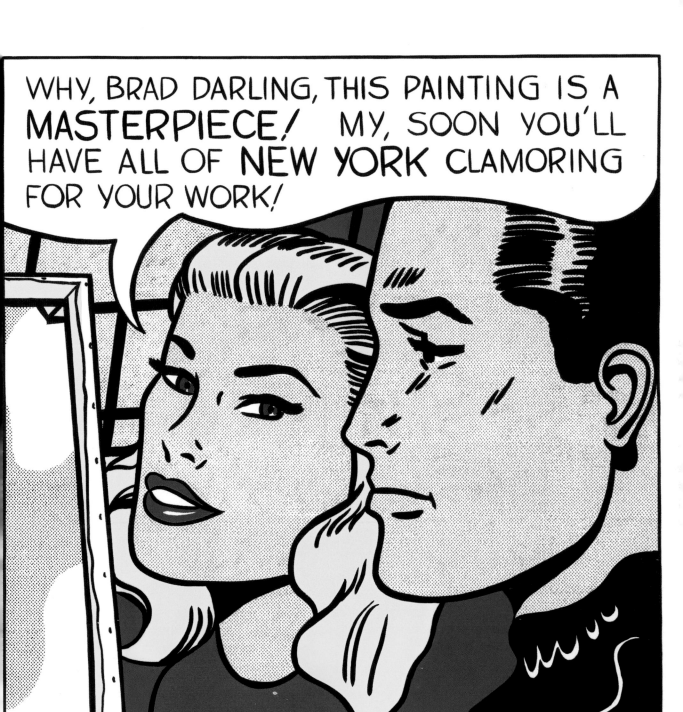

Roy Lichtenstein, **Masterpiece**, 1962,
oil on canvas, 54 x 54 in. (137.2 x 137.2 cm), private collection,
New York

ANDY WARHOL
Campbell's Soup Cans

Andy Warhol jealously watched other artists' careers take off. Claes Oldenburg's 1961 *The Store* created a sensation. Green Gallery in January 1962 showed James Rosenquist's big paintings of such subjects as a 7-Up bottle. Lichtenstein's sellout show in 1962 featured cartoon imagery, which Warhol felt had been inspired by his own cartoon paintings exhibited in April 1961 in the windows of Bonwit Teller (pp. 42/43). Warhol was so despondent about these sensational successes, while he received no recognition, that he refused a dinner invitation from his friend Ted Carey, but he agreed to let Ted and their mutual friend Muriel Latow, an interior designer and art dealer, come by after dinner. As Ted Carey recalls, "He said, 'the cartoon paintings ... it's too late. I've got to do something that really will have a lot of impact that will be different enough from Lichtenstein and Rosenquist, that will be very personal, that won't look like I'm doing *exactly* what they're doing.'... So, he said, 'Muriel, you've got fabulous ideas. Can't you give me an idea?' And, so, Muriel said ... 'you've got to find something that's recognizable to almost everybody. Something you see every day that everybody would recognize. Some-thing like a can of Campbell's Soup.' So Andy said, 'oh that sounds fabulous.' So, the next day Andy went out to the supermarket—because we went by the next day—and we came in, and he had a case of ... all the soups." Andy Warhol wrote Muriel Latow a fifty-dollar check for that idea.

In April 1962, Wayne Thiebaud's sellout solo show at the Allan Gallery featured paintings of popular American foods.

Andy Warhol's Pop Art solo debut at the Ferus Gallery in Los Angeles in July 1962 consisted of silkscreened paintings of larger-than-life cans of the thirty-two available flavors of Campbell's Soup, priced at $100 each. Only six sold during the show, the first one to actor Dennis Hopper, but the gallerist Irving Blum bought those back to keep the set together, paying Warhol $1,000 over ten months for the set. In 1996, Blum sold the set to MoMA for $15 million.

The L. A. reception of the soup can paintings was caustic and derogatory, but Marcel Duchamp observed, "If you take a Campbell's soup can and repeat it fifty times, you are not interested in the retinal image. What interests you is the concept that wants to put fifty Campbell's soup cans on a canvas."

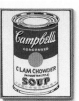 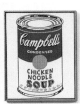 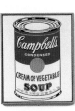 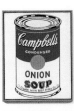 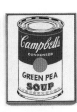 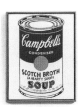 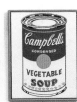

 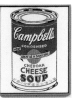 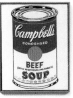 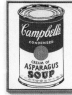 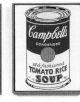 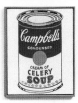

 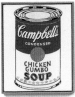 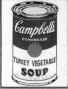 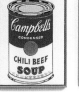 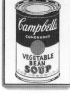

 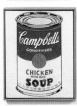 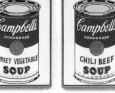 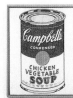 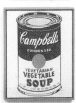 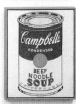

Andy Warhol, **Campbell's Soup Cans**, 1962,
synthetic polymer paint on canvas, 32 parts, each 20 x 16 in.
(50.8 x 40.6 cm), The Museum of Modern Art, New York

ED RUSCHA
Twentysix Gasoline Stations

1962

When Ed Ruscha worked part-time for book printer Saul Marks, the owner of Planton Press, he learned how to set type, became attracted to books, and saw possibilities for his work within bookmaking.

This book of photographs contains exactly what is promised by the title, which is printed in three lines of red type on the cover. The title and the concept of the book were more important to Ruscha than the twenty-six photographs, which, as in his other photo-based artist books, were, he says, "recorded with no prejudice, and recorded with no agenda, and no moral or no principle." They point, though, to the omnipresence of the car, and the necessity to keep gassing it, and that in turn highlights the absence of people—or other vehicles.

The book is a foundational work in photo-based Conceptual Art, and mirrors several of Ed Ruscha's artistic concerns as a Pop artist. His images are blunt, bland, and colorless records of fragments of everyday life, drawn from the sphere of commercial architecture, complete with its signage. Some are printed as spreads, most are full page, some are combined on a single page. Apart from captions that record the locations, Ruscha "eliminated all text from my books—I want absolutely neutral material. My pictures are not that interesting, nor the subject matter. They are simply a collection of 'facts,' my book is more like a collection of readymades."

Except for the turnaround point, the stations stud the return drive between Los Angeles and Oklahoma on Route 66, already ingrained in popular imagination by a TV series of that name and featured in John Steinbeck's *The Grapes of Wrath*.

Critic David Hickey remarks, "Ruscha's book nailed something that, for my generation, needed to be nailed: the Pop-Minimalist vision of the Road. Jack Kerouac had nailed the ecstatic, beatnik Road. Ken Kesey and Neal Cassady were, at that moment, nailing the acid-hippie Road, and now Ruscha had nailed the road through realms of absence—that exquisite, iterative progress through the domain of names and places, through vacant landscapes of windblown, ephemeral language."

Less enthralled, the Library of Congress, which is obligated to archive all books, rejected Ruscha's. He trumpeted his achievement in an ironic 1964 *Artforum* advertisement.

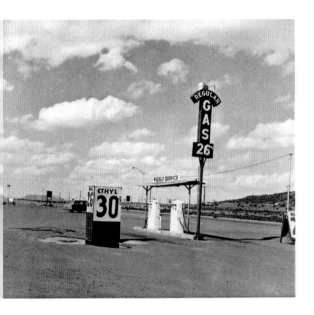

Ed Ruscha, **Twentysix Gasoline Stations**, 1962,
gelatin silver prints, clockwise from top left: Self Service, Milan, New Mexico.
Texaco, Vega, Texas. Conoco, Albuquerque, New Mexico, 4.69 x 5 in.
(11.9 x 12.7 cm). Untitled Gas Station, 5 x 7 in. (12.7 x 17.8 cm)

ANDY WARHOL
Marilyn Diptych

Marilyn Monroe's "probable suicide" in August 1962 shocked much of the world. *Paris Match* said, "Her beauty of face and figure and sweetness of spirit had brightened the world of untold thousands of men and women…. They found life sweeter because she lived and sadder because she died." It was a sobering American tragedy. What value could the American Dream hold if this sex symbol—idolized by millions, with her rags-to-riches story and series of glamorous mates—having achieved it would rather die? Had it been an accident? Could dark motives have conspired to kill her and cover it up?

Warhol silkscreened several paintings of Marilyn after her death, based on a publicity still from the 1953 film *Niagara*. The Tate, the current owner of the work, remarks, "Warhol found in Monroe a fusion of two of his consistent themes: death and the cult of celebrity. By repeating the image, he evokes her ubiquitous presence in the media." The contrast of luscious color with the ashen tones fading into oblivion suggests the star's mortality. The fifty repeated images suggest film frames. The diptych, reminiscent of Christian icons, beatifies Marilyn as a celebrity icon. (Warhol's family followed Byzantine rites; Warhol was devout.)

In 1962, Andy Warhol was dying for recognition. His comeuppance arrived in November, when Alex Katz cancelled his planned show at Stable Gallery, and the owner, Eleanor Ward, visited Warhol's studio. She liked what she saw, pulled a lucky $2 bill out of her purse, and offered Warhol a solo show if he'd paint it. The show's eighteen works, including *Marilyn Diptych* and Warhol's serial images of dollar bills, all sold.

Andy Warhol was literally painting money in 1962. After Warhol's sell-out show of *Flowers* at the Leo Castelli Gallery in 1964, Thomas Hess remarked, "Warhol is the brightest of Pop artists" and his achievement is to make "empty metaphysical vessels that are continually being filled with real money, which is an undeniable triumph, sociologically." In 2009, Warhol's 1962 *200 One Dollar Bills* sold for $43.8 million. Today, it is sometimes difficult to see beyond the financial and investment value of Pop Art—it has become a fetishized commodity.

In 2004, five hundred art experts voted the *Marilyn Diptych* the second most influential artwork of the twentieth century.

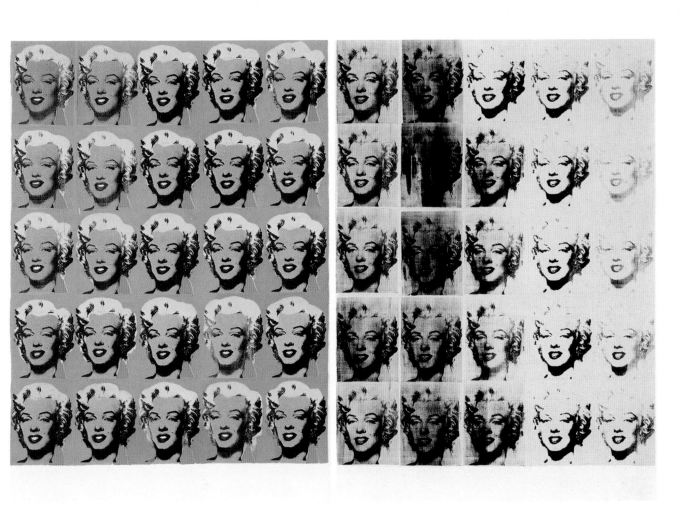

Andy Warhol, **Marilyn Diptych**, 1962,
acrylic on canvas, 80.9 x 114 in (205.4 x 289.6 cm), Tate, London

KIKI KOGELNIK
Bombs in Love

Acutely conscious of the debates of the era, Kiki Kogelnik's *Bombs in Love* expresses the tension between love and war. Opposites can oppose one another, but also attract magnetically. Her missiles, pop-painted in red-green/ stop-go camouflage, reflect the nuclear threat of the Cold War and the surreal Vietnam War that divided America. This sex-death dialectic also features in her collage *No Love* (1970), which shows a profile of a dissected skull with a phrenology zone marked "no love," and in her *Skull* (1970), a giant vanitas emblem made of multicolored plastic.

Kogelnik's *War Baby* (1972) shows a hip young woman wearing an orange afro, psychedelic sunglasses with concentric colored circles, and camouflage-print hotpants. *War Baby* could be Kogelnik: she grew up in Austria during World War II. Settling in America in 1961, Kogelnik mixed in Pop circles. Dressed flamboyantly, she was like a one-person happening. She presented herself at parties as the Love Goddess of Pop, dressed in faux zebra skin, an aluminum helmet, and a silver wig.

Uninterested in consumerism and mass marketing, she said: "I'm not involved with Coca Cola.... I'm involved in the technical beauty of rockets, people flying in space and people becoming robots. When you come here from Europe it is ... like a dream of our time. The new ideas are here, the materials are here, why not use them?" "Art comes from 'artificial,'" she said.

Kogelnik's idealism about the future and her embrace of new plastics, vinyl, and metallic foils infused her paintings and assemblages. Many works are peopled by cutout figures, the silhouettes drawn or spray-painted around model friends, often famous artists. These shadow figures float in space among dot-bubble forms, sometimes wearing astronaut helmets, sometimes accompanied by birds and guns.

Kogelnik used figure cutouts of vivid vinyl in a series of *Hangings* works. Hung on a rolling clothes rack for *Seventh Ave. People* (1968), for example, these plastic tracings were like skins for sale among the garments in New York's Fashion District where Kogelnik lived.

In 1969, Kogelnik's *Moonhappening* in Galerie nächst St. Stephan, Vienna, involved silkscreening spaced-themed works during the lunar landing—inaugurating the type of real-time simultaneity typical of a future media era—today's.

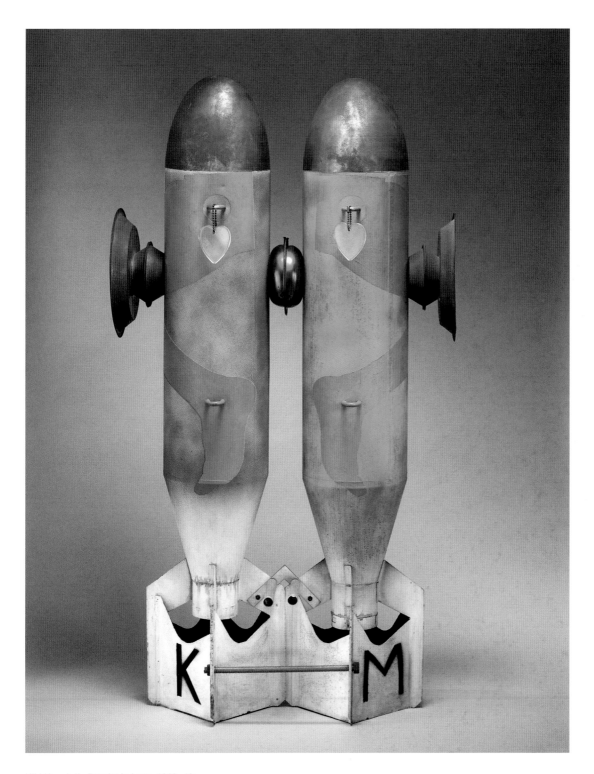

Kiki Kogelnik, **Bombs in Love**, 1962–63,
metal army bombs, acrylic, plastic,
48 x 9.8 x 24.8 in. (22 x 25 x 63 cm),
Kiki Kogelnik Foundation, Vienna/New York

ANDY WARHOL
Triple Elvis

Warhol's life-size Elvis Presley paintings show the all-American rock star cum celebrity cum sex symbol-as-cowboy hero, as shot for a publicity still for his 1960 film *Flaming Star*. Warhol intensifies the sexual charge of the pose—legs apart, gun and gaze directed at the viewer—by overlapping the three idols and their guns at the crotch, conflating sex and death. This cowpoke pose was a trope in gay pornography and physique magazines. Elvis stutters in multiple, like a movie jumping in a projector, or a figure seen in a strobe light or photographed in a stop-motion sequence.

Warhol produced an Elvis series and a series of Liz Taylor, both screened onto silver spray-painted canvas, as a male-female duo for his second show at the Ferus Gallery in L. A. The Elvis image was silkscreened twenty-eight times in black ink on long rolls, which Warhol shipped with stretcher bars to the gallerist Irving Blum. He told Blum to cut the canvases any way he chose, but to install the stretched works as close together as possible. Hung, they created a mural effect. Warhol likely intended the repetitions to refer to Duchamp's *Nude Descending a Staircase*, the work used to advertise Duchamp's retrospective that opened in Pasadena a week after his Ferus show. Warhol had never ventured west of Pennsylvania, but drove to L. A. to attend both openings and meet Duchamp.

Warhol recalled, "Very few people on the [West] Coast knew or cared about contemporary art, and the press for my show wasn't too good. I always have to laugh, though, when I think of how Hollywood called Pop Art a put-on! *Hollywood*?? I mean when you look at the kind of movies they were making then— those were supposed to be real???"

Hollywood's silver screen was passé for Warhol's set. For them silver was the future, and formed the backdrop of their work in the Silver Factory—including Warhol's avant-garde films that opposed Hollywood in every way, not least in the sexuality Warhol's "stars" projected. While in L. A., Warhol began filming *Tarzan and Jane Regained, Sort of ...*, his title a play on Duchamp's *The Bride Stripped Bare by her Bachelor, Even*— both works present sexual pairs quite unlike Hollywood's Elvis and Liz!

Not one painting sold during the 1963 Ferus show, but in 2008 the show's largest canvas, the twelve-foot *Eight Elvises*, sold privately for $100 million.

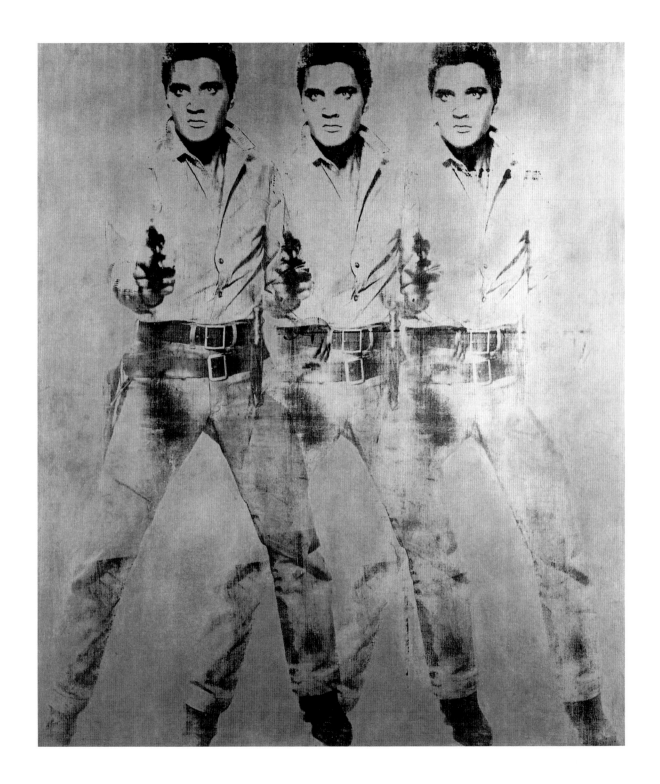

Andy Warhol, **Triple Elvis**, 1963,
aluminum paint and printer's ink silkscreened on canvas,
82.4 x 71.1 in. (209.2 x 180.7 cm), Virginia Museum of Fine Arts,
Richmond

MARISOL
John Wayne

Marisol's undeserved reputation as the sphinx of Pop, even more inscrutable than her friend Andy Warhol, pales in light of Marisol's sharp statements, both in interviews and in her work.

Life magazine commissioned this work for its December 20, 1963 issue on the movies. Marisol was, by then, already a known and glamorous artist herself. *Life* published a full-color spread of *John Wayne* right after a focus on John Wayne, hailed as "king of the cowboys." Some saw Marisol's *John Wayne* as glorifying a star, like Warhol's *Marilyns*, but it is a satirical riff on the super-macho image that Wayne embodied. "I never liked John Wayne," Marisol said, and she felt he couldn't act—and it shows in this work.

Wayne is wooden, a flat cutout—but that could apply to several of Marisol's figures, which are typically composed of wood with images applied by drawing or incised into the surface. Marisol often includes found elements, cast-plaster sections, and images of her own face. Wayne has his own faces. His box head has portraits drawn on the three sides of the block. On the left side, Marisol drew a frontal portrait with staring eyes; on the right, she drew his face slightly turned; on the rear she drew his head

protruding from a tuxedo. For the front face, Marisol pasted a publicity photo of the actor in a suit and tie, posed, smiling. Wayne has three hands, too. Two hold guns. The third is detached from the body, draped on the phallic pommel, as if caressing it with flaccid feminine fingers—the hands are casts of Marisol's.

Marisol based the splayed horse on a Mexican toy. She turned the heroic motif of the mounted cowboy, looking for trouble, into a folksy weathervane—passively swiveling with the wind. The colors in the sculpture evoke the American flag, linking cowboy and country. The result is ironic and humorous.

Many Pop artists glorified mass-media images and consumerism, but Marisol was among those who "revealed what was going on behind the American dream—the fate of those untouched by postwar prosperity, the loneliness engendered by an atomized society, the emptiness of material success."

Social critique usually stems from humanistic impulses, and Marisol's tenderness is clear when portraying figures she admires—like Archbishop Desmond Tutu and Marcel Duchamp—and causes she empathizes with, such as the plight of the poor.

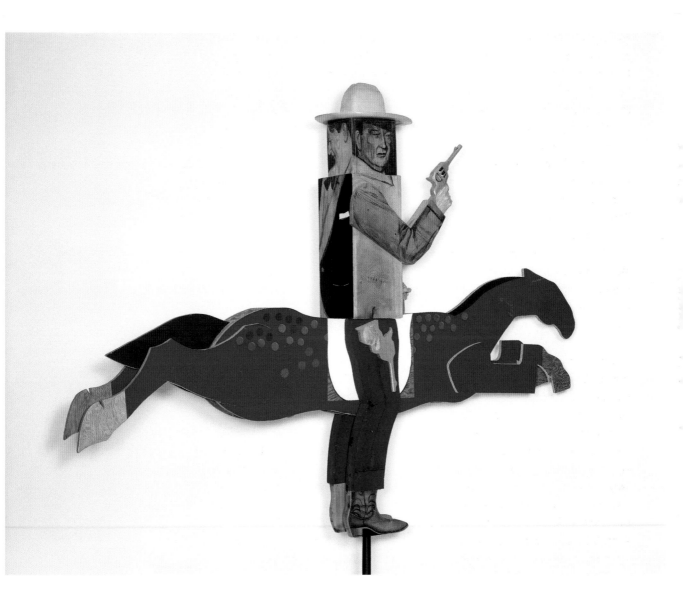

Marisol, **John Wayne**, 1963,
wood, mixed media, 104 x 96 x 15 in. (264.2 x 243.8 x 38.1 cm),
Fine Arts Center, Colorado Springs

MARJORIE STRIDER
Girl with Radish

Marjorie Strider produced striking Pop works during the 1960s, but her importance has been overlooked until recently. Her *Girls* series (1962–64) contains classic Pop elements—cartoonish, stereotyped views of attractive women, cropped as in comics or advertising, but scaled up larger than life, and painted with flat backgrounds and bright colors. But her *Girls* include extraordinary plastic protrusions Strider called "build outs," which push them into the territory of sculpture and into the viewer's face: pert, bikini-cupped breasts, bulging backsides, and bright red lips, which look like orifices on sex dolls—and that is the rub. Strider renders explicit the sexism of Madison Avenue and of popular culture by accentuating the most "attractive" cum marketable attributes—making them *more* palpable, more graspable than the women that they belong to.

In *Girl with Radish* the three-dimensional vegetable looks like a lollypop or sucker, and suggests fellatio, while the built-out mouth becomes a *vagina dentata*—a biting reference to the possibility of castration and a subversion of popular imagery. The girl's mascara-laden eyelashes also extend into space.

Strider's work was an inspiration for *The First International Girlie Show* at New York's Pace Gallery in January 1964. *Girl with Radish* was adapted for the exhibition banner, without the radish. "I was making a satire of men's magazines," Strider said, but the *New York Times* critic John Canaday read her work as "additional proof that, when you face it, girlies are really repulsive," as if Strider was critiquing the women rather than their commodification. This shows how easily women's artwork that used the female form could backfire and reinforce ideas they opposed.

In *The First International Girlie Show*, Strider's work appeared alongside paintings by Andy Warhol, Roy Lichtenstein, and Tom Wesselmann, but she—like Rosalyn Drexler, also in the show—never matched the recognition the male artists received until recent reappraisals of the work of women artists during the Pop era, which highlight the sexist environment they faced and how this forestalled the recognition they deserved. "I always thought I'd be famous," Strider says. "You know, like Lichtenstein or something. That's why I never had children. I knew I couldn't do both, and do both well. So ..."

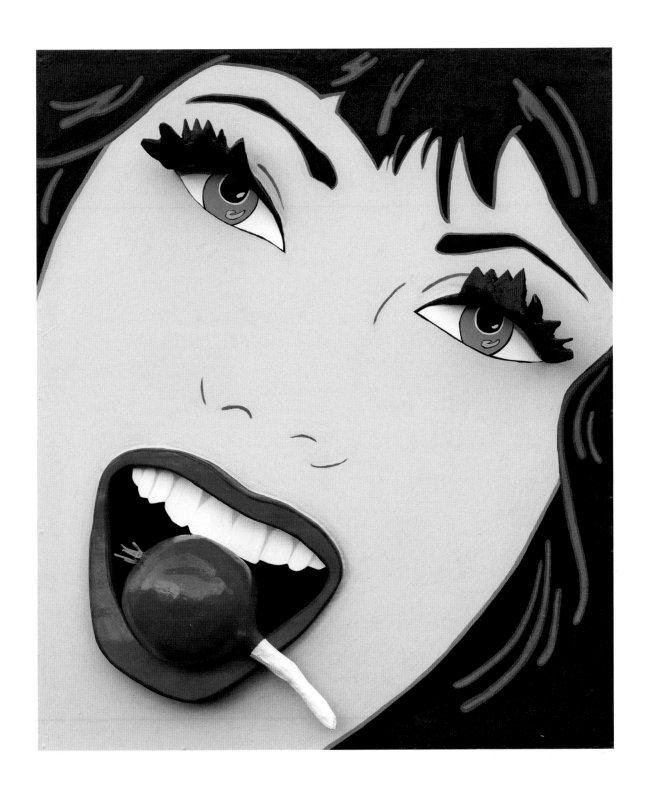

Marjorie Strider, **Girl with Radish**, 1963,
acrylic, laminated pine on masonite,
72 x 60 in. (182.9 x 152.4 cm), private collection

ROBERT RAUSCHENBERG
Retroactive I

Rauschenberg described himself as working in the "gap between art and life." The commercial silkscreen technique—which he discovered on a 1962 visit to Andy Warhol's studio—enabled him to transpose image fragments of daily life, which he loved to collect, onto canvas, shifting their color and scale and determining their juxtapositions.

Retroactive I and his other early silkscreen paintings respond to the media age and, as a dyslexic, his own way of seeing. The surfaces of these paintings "invited a constant change of focus and examination of detail." Rauschenberg explained, "I was bombarded with TV sets and magazines, by the refuse, by the excess of the world.... I thought an honest work should incorporate all of these elements, which were and are a reality. Collage is a way of getting an additional piece of information that is impersonal. I've always tried to work impersonally."

Rauschenberg began this painting before President Kennedy's assassination on November 22, 1963. After the tragic news shattered the nation, Rauschenberg "reworked it into a meditation on Kennedy's death and on the central place he had assumed,

through his martyrdom, in modern American mythology." Kennedy's pointing hand recalls both Michelangelo's image of the Creator reaching out to Adam in the Sistine Chapel, and recruitment posters—"your country needs you"—while the cloudlike, mushroom-hued halo over Kennedy's head suggests the nuclear showdown Kennedy deftly avoided. The red image in the lower right corner reproduces a photograph by Gjon Mili, published in *Life* magazine, that parodies Marcel Duchamp's celebrated painting *Nude Descending a Staircase* (1912)—itself based on sequential photos of a body in motion. The slow-motion effect recalls the frame-by-frame replays of the assassination in Dallas. The art critic Robert Hughes pointed out that this red image "recalls the figures of Adam and Eve expelled from Eden in Masaccio's fresco for the Carmine in Florence." Florida's Sunkist oranges replace Eden's apple in this image of America's fall from grace; an astronaut floats like an angel; the green glass suggests Christian Mass and martyrdom; and Rauschenberg said that the image of a construction worker (top right) reminded him of the figure of Adam in the Sistine Chapel.

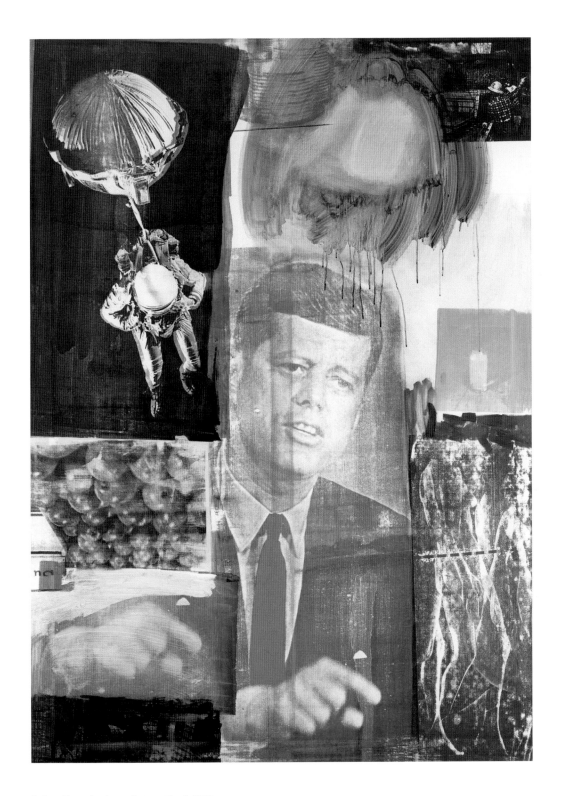

Robert Rauschenberg, **Retroactive I**, 1963,
oil and silkscreen ink on canvas, 84 x 60 in. (213.4 x 152.4 cm),
Wadsworth Atheneum, Hartford

ROY LICHTENSTEIN
Whaam!

1963

Roy Lichtenstein's cartoon-style images and his technique of laborious hand-painted dots, which mimic Ben-Day dot screens used in commercial printing, are today a globally recognized cliché of Pop Art.

His best-known early works are drawn from war and romance comics, but he also used images from advertising and other aspects of everyday life. The painting on the cover of this book is a witty reference to the instant fame that followed Lichtenstein's February 1962 show at Leo Castelli Gallery—which sold out before the night of the opening. Conservative critics initially described his work as "empty headed," "jokey," "dumb"; the New York Times hailed him as one of the worst artists in the world, and Life magazine agreed. In fact, Lichtenstein's works are more complex than they seem. To heighten their aesthetic impact, he altered the source image, its colors, its speech bubble, its text, and dramatically enlarged it. "I am calling attention to the abstract quality of banal images," he said.

Whaam! was based on an image in DC Comics' All-American Men of War #89 (1962), drawn by Irv Novick, that showed an American pilot destroying an enemy plane. A comparison with the original reveals the many formal adjustments Lichtenstein made to condense his image, simplifying, eliminating, or repositioning some visual elements, completely redrawing others. He turned the image into a diptych, which heightens the opposition of hero and enemy, cause and effect, life and death.

"A minor purpose of my war paintings is to put military aggressiveness in an absurd light. My personal opinion is that much of our foreign policy has been unbelievably terrifying, but this is not what my work is about and I don't want to capitalize on this popular position. My work is more about our American definition of images and visual communication."

Whaam! was a star of Lichtenstein's 1963 show at Castelli's, and today it is one of the best-known works of the twentieth century. However, the Tate's purchase of the painting for about $6,000 in 1966—when the average working man earned $2,000 per annum—was strongly opposed. Today, Whaam! is invaluable, and hundreds of thousands of visitors have attended Lichtenstein retrospectives.

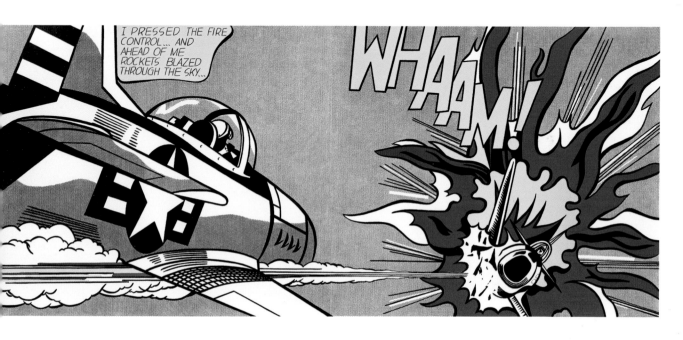

Roy Lichtenstein, **Whaam!**, 1963,
acrylic and oil on canvas, 2 parts, each 68 x 80 in.
(172.7 x 203.2 cm), Tate, London

ANDY WARHOL
Sleep

Warhol made hundreds of movies between 1963 and 1968, when he was nearly assassinated and withdrew from filming personally. His revolutionary approach to film opposed all conventional film, especially Hollywood.

Warhol's first long film, *Sleep*, engaged cinema's illusion of unfolding narrative in "real time," which is normally a condensed time frame. Warhol conceived *Sleep* as a static shot recording eight hours of sleep in real time. The actor would not be performing, but *really* sleeping—exhibiting sleep. Nor was he an actor, but a gay poet and stockbroker, John Giorno, with whom Andy sometimes shared a room on weekend getaways to Old Lyme, Connecticut that included such other Pop artists as the Oldenburgs, Marisol, and Robert Indiana. Andy, always speedy from his daily dose of the amphetamine Obetrol, had trouble sleeping. One night, Giorno awoke to find Andy staring at him, amazed at how well he slept. Andy proposed a film of Giorno sleeping. Soon the *Village Voice* announced that Warhol planned "the longest and simplest movie ever made, an eight-hour-long movie that shows nothing but a man sleeping." This concept was enough to gain Warhol

recognition not only within the New York avant-garde film circle he had been exploring but also within film history.

To execute Warhol's plan proved an arduous task for an amateur using basic equipment. Every three minutes, the film roll had to be replaced—which took twice or three times as long—and the camera had to be wound twice a minute. During many nights' work, Warhol began to deviate from his plan of a static shot that would have been like staring at a "breathing painting." Eventually, he edited twenty-eight minutes of film, spliced it repeatedly to make up five hours and twenty-one minutes, and projected it at two-thirds speed.

Sleep is voyeuristic, but mostly it is soporifically boring, despite the occasional movements of camera and subject, which scarcely entail "action."

Warhol followed with *Kiss*, a silent series showing twelve gay and straight couples kissing for three minutes each, in flagrant violation of Hollywood's rule at the time that onscreen kisses be limited to fifteen seconds. Again, Warhol projected *Kiss* slowed down, queering the effect, deferring the eroticism that becomes overt in several of Warhol films produced after 1968.

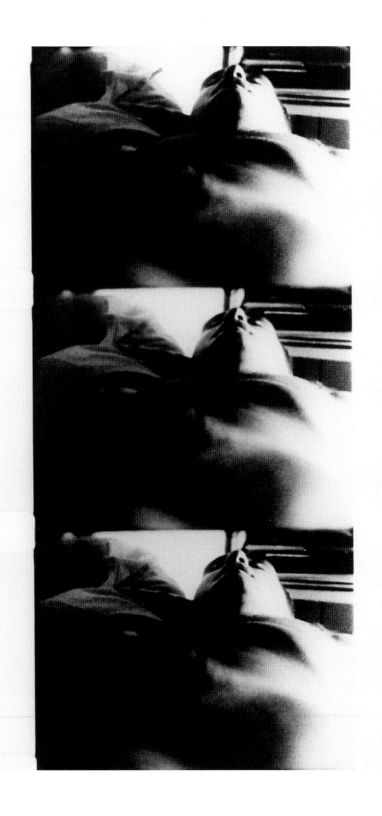

Andy Warhol, **Sleep**, 1963,
film

WAYNE THIEBAUD
Pie Counter

1963

Wayne Thiebaud describes himself not as an artist, or a Pop artist, but as a painter—and he is a painter's painter.

Thiebaud was raised in California, and it shows. His magnificent landscapes of San Francisco and Sacramento reflect the natural setting, and his treatment of flat planes reflects the influence of fellow Californian painter Richard Diebenkorn. It is for his paintings of cakes and candies, however, that Thiebaud was instantly hailed as a Pop hero. His 1962 exhibition at the Alan Stone Gallery in New York was reviewed in the *New York Times*, *Art News*, *Life*, and *Newsweek*. It led to his inclusion in two further exhibitions in 1962 that were key in establishing Pop Art: *New Painting of Common Objects*, curated by Walter Hopps at the Pasadena Art Museum, and Sidney Janis Gallery's *International Exhibition of the New Realists* in New York. Thiebaud's paintings of popular American foods from the diner, the deli, and the downtown mall resonated with Warhol's deadpan Campbell's soup cans and Coke bottles and Claus Oldenburg's plaster sculptures of gooey edibles. As a teenager, Thiebaud had worked in "a café called Mile High & Red Hot—the ice creams were tall and the wieners were hot"—and got a summer job cartooning at the Disney studios. "My own sense is being American is a very important part of what I feel and do," Thiebaud said in a 2011 interview.

In *Pie Counter* and other paintings, Thiebaud's mass-produced consumables seem to be self-replicating, reproducing out of control behind the scenes, and rolling out on a conveyer belt. In the words of Wayne Thiebaud's favorite poet, William Carlos Williams, these "pure products of America go crazy." The closer one looks at the pies in Thiebaud's *Pie Counter*, the more one notices suspiciously lurid colors in the outlines and shadows of the dreamy, creamy treats—enough to make one queasy. Heightening the slightly sinister appearance of Thiebaud's colorific confections, the sensitive viewer is likely to be reminded of America's plague of obesity, which actually results more from too little real food than from too much. One person in eight in America goes hungry today. The plenty of the American Dream is mostly illusion.

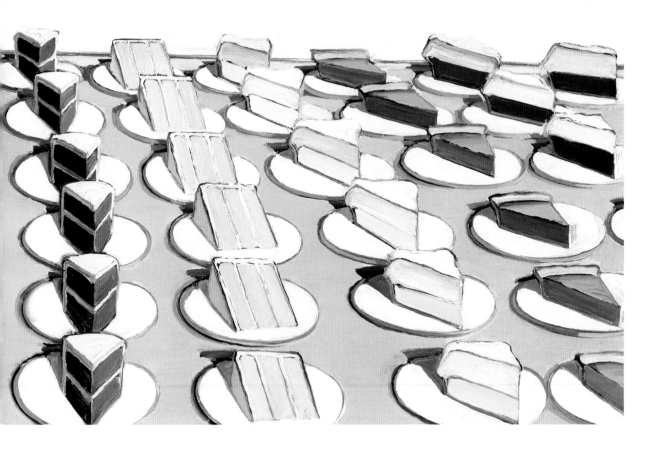

Wayne Thiebaud, **Pie Counter**, 1963,
oil on canvas, 30 x 36 in. (76.2 x 91.4 cm),
Whitney Museum of American Art, New York

ANDY WARHOL
Flowers

Warhol's flowers cannot simply be taken at face value. To begin with, they were stolen flowers, cropped from an image in *Modern Photography* by executive editor Patricia Caulfield. She sued for copyright infringement. Offered two portfolios of *Flower* prints to settle, she declined in favor of a cash settlement.

Warhol made several *Flower* paintings in various square dimensions as the sole subject for his 1964 show at Leo Castelli Gallery. He upped the contrast of the original image, extracted and replicated the dark centers, and chose unnatural colors. His flowers departed from nature.

Andy Warhol's assistant for ten years, Ronnie Cutrone, explains that Andy's in-crowd at the Silver Factory knew the *Flowers* were menacing statements about life and death: "Lou Reed, Silver George Milloway, Ondine, and me—we all knew the dark side of those *Flowers*. Don't forget, at that time, there was flower power and flower children. We were the roots, the dark roots of that whole movement. None of us were hippies or flower children. Instead, we used to goof on it. We were into black leather and vinyl and whips and S&M and shooting up and speed. There was nothing flower power about that. So

when Warhol and that whole scene made *Flowers*, it reflected the urban, dark, death side of that whole movement."

The flowers have also been given a darker name: they resemble countless close-ups of anuses in contemporary gay pornography magazines—an alternative type of "modern photography" that Warhol avidly consumed. Artist and critic Steve Cox points out that the flowers nestle "in grass which has an ugly, hair-like quality. In their naked starkness, these are debased, abject 'pornographized' flowers." Warhol mobilized similar associations in several other works. His 1971 installation *Daisy Waterfall (Rain Machine)* consists of seventy daisies, printed on a glossy plastic curtain; in front of them "rain" continually falls into urinal-like troughs. Cox says that Warhol's identical, repeated daisies—or Hollywood stars or other objects—refer to homosexual sameness, and this work brings to mind the gay slang term "daisy chain," meaning a row of men engaged in sex acts.

In 1982, after AIDS had become a topic of mainstream discussion, Warhol proposed to cover the Tacoma Dome with a red-and-black "decidedly sphincter-like flower."

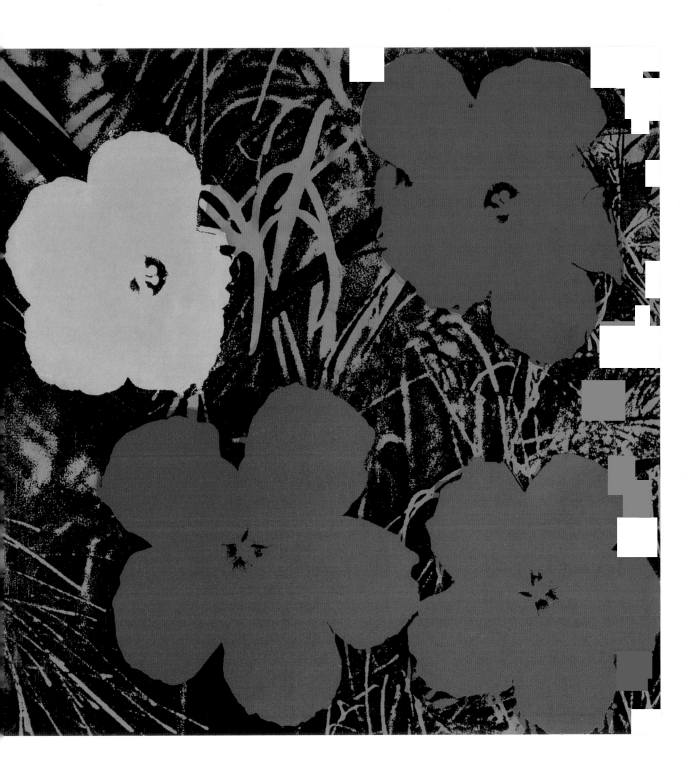

Andy Warhol, **Flowers**, 1964,
silkscreen on acrylic on canvas, 24 x 24 in. (61 x 61 cm),
José Mugrabi Collection

IDELLE WEBER
Munchkins I, II, & III

Idelle Weber's hard-edge silhouette of a typist, *Office I* (1960–61), was the first of several iconic paintings of workers and other social types, which included *Munchkins I, II, & III*. Weber's flat and laboriously gridded surfaces in this and other works recall comics and commercial imagery—both typically Pop. *Munchkins* shares the anomie that haunts Edward Hopper's work, whom Weber cites as an influence.

Weber's "munchkins" are the little people in the bigger scheme, the functionaries, the worker ants. This triptych of male workers in suits and hats riding escalators sums up the landscape of early sixties New York, with modernist masterpieces like Lever House as corporate skyscrapers—complete with entrenched exclusionary devices.

Sexism inhibited recognition of Weber's work. Her Artnet site records the following chronology for 1957 alone: Although Weber's drawing is included in *Recent Drawings USA* at MoMA, which buys it, the art historian Horst Jansen tells her he does not include women painters in his art textbook; the gallerist Charles Allen tells her he does not show women artists. She wins third prize in a juried show (Warhol also wins one); is included in juried shows at the Pennsylvania Academy of the Fine Arts, the Springfield Museum of Fine Arts, and for the American Federation of Arts; has illustrations commissioned by *Esquire* and *Scholastic* magazines, but Robert Motherwell tells her that married women with children, like Weber, "should not audit classes because they would not continue painting," and refuses to admit her to his classes at Hunter College.

The progressive movements of the 1960s helped change that discriminatory world, but Weber's contribution was not widely appreciated until Sid Sachs's 2010 *Seductive Subversion* exhibition.

Ivan Karp, of Leo Castelli Gallery, supported Weber's work and introduced her to gallerists and other Pop artists. Among the artists she befriended were Yayoi Kusuma, Lucas Samaras, and Claes and Patty Oldenburg. In 1962, Weber's works from this businessman series were shown at Dwan Gallery in L.A., and she signed with Bertha Schaefer Gallery in New York.

Like many Pop artists, Weber embraced new materials, particularly Plexiglas and neon, which she combined in her relief wall sculpture *Jumprope Lady* (1965).

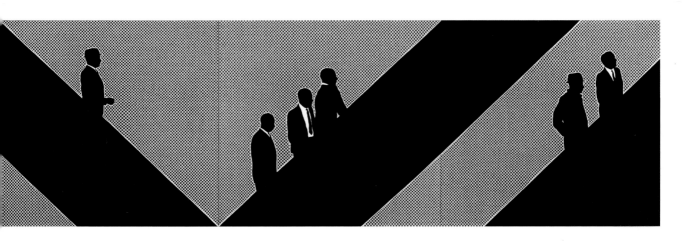

Idelle Weber, **Munchkins I, II, & III**, 1964,
acrylic on linen, 72 x 214 in. (182.8 x 543.6 cm),
Chrysler Museum of Art, Norfolk

JOYCE WIELAND
Young Woman's Blues

Canadian Joyce Wieland first worked in commercial art and animation. She began to use canvas as a fabric—unstretched, sewn, and stained—before she settled in New York in 1962, and became influenced by Claes Oldenburg, who was in turn inspired by Yayoi Kusama's soft sculptures. Among Wieland's soft-sculpture works are some made of colored, transparent plastic, which she assembled into a hanging series of pockets stuffed with small objects, including film strips and images. Such works as *Stuffed Movie* (1966) look like strips of multicolored film. She made several films, and dyed some film stock with the colors she used in her fabric works. She extended quiltmaking into large works that became a form of "soft painting," and used other "female" handicrafts.

In the early sixties, Toronto had a Duchamp revival, which apparently influenced Wieland's approach to found objects and assemblage. After settling in New York, she visited Duchamp several times. *Young Woman's Blues* is one of several assemblages created in and around found crates, and often titled after labels found on the crates. *Young Woman's Blues* includes the iconic Pop images of Liz Taylor, the heart, and a jet—the first transatlantic jet service began in 1958. Flying was glamorous and expensive. Those who could afford it in the sixties were the "jet set." Wieland's work appears to have gathered a set of aspirational/inspirational icons into a devotional shrine for a Young Woman. Love, celebrity, and flying can all be let-downs, however—as witnessed by Liz Taylor's disastrous marital record and airplane disasters. The dark underside of the dream, and especially what Wieland saw as an American media obsession with disaster, was the subject of many of her paintings of the early sixties.

Wieland preferred to show in Canada rather than in the New York art world's rat race; this short-circuited recognition of her work. She moved back to Toronto in 1971 when her solo show opened at the National Museum of Canada—that institution's first for a woman artist. The influential Anthology Film Archives in New York overlooked her contributions to avant-garde film. "The men in that movement, including my husband, were no more enlightened than any other men at the time. They failed to treat me as their equal as an artist."

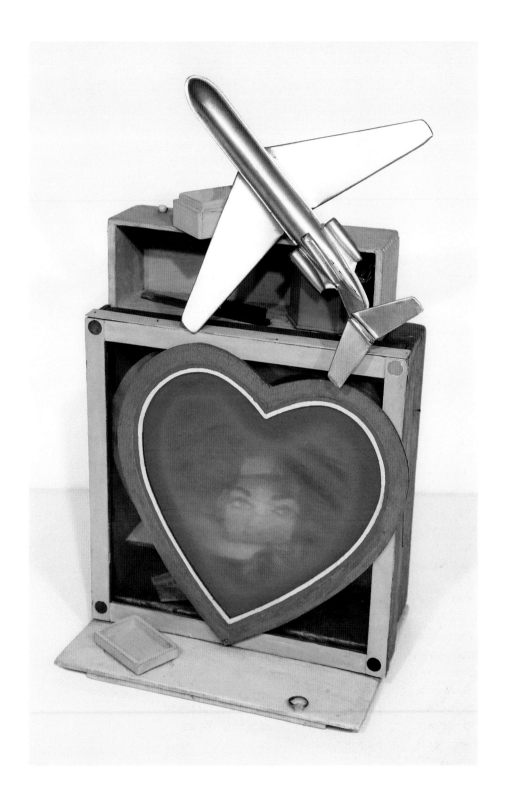

Joyce Wieland, **Young Woman's Blues**, 1964,
mixed media, 12.5 x 13 x 9 in. (31.8 x 33 x 22.9 cm),
University of Lethbridge Art Gallery, Alberta

ROBERT RAUSCHENBERG
Shades

Shades features Robert Rauschenberg's innovative adoption of new media and his blurring of the boundaries between art disciplines. Conventionally, lithograph prints are works on paper, framed, and displayed on a wall. Here Rauschenberg prints images onto five transparent plastic panels, like the pages of a book. The "cover" sheet carries the title. Discarded *New York Times* plates provided some of the imagery, combined with other additions. These plastic "pages" are slotted into a construction, which stands on a tripod: it becomes a sculpture.

Rauschenberg exploits the transparency of the plastic. He invites the viewer to look through the five "pages," on which the images become visible only because they shade out the intermittent light. The images are negatives that come to life when light passes through briefly, like a camera, which the sculptural form resembles. The boxy shape and the flickering light are also reminiscent of television, an increasingly omnipresent and influential medium in the 1960s.

Shades is designed for viewers to alter the order and orientation of the plastic panels. It invites performance.

"Mathematicians have calculated that there are over six million different arrangements of *Shades*." Given the numerous possibilities, any particular arrangement reflects a high degree of chance. *Shades* destabilizes the idea of the artwork as a static image, or even as a singular object. It makes the viewer an integral part in determining the work's identity and appearance at any moment in time; yet the light comes and goes, making the work appear and disappear, and asserts the artist's intention. Of course, in a museum where visitors may not touch or activate the works, this work is about as engaging as a television switched off. Rauschenberg liked to work with the television on.

A dyslexic, Rauschenberg tended to "see everything in sight," "see things in fragments," and "see backwards and forwards at the same time." These perceptual and cognitive differences help explain elements of Rauschenberg's work, and they seem apt for *Shades*—a work that seems singular yet fragments and recombines in millions of ways. *Shade* can be viewed as Rauschenberg's answer to a dyslexic's struggle with the book. Rauschenberg dedicated *Shades* to his son, Christopher, a photographer.

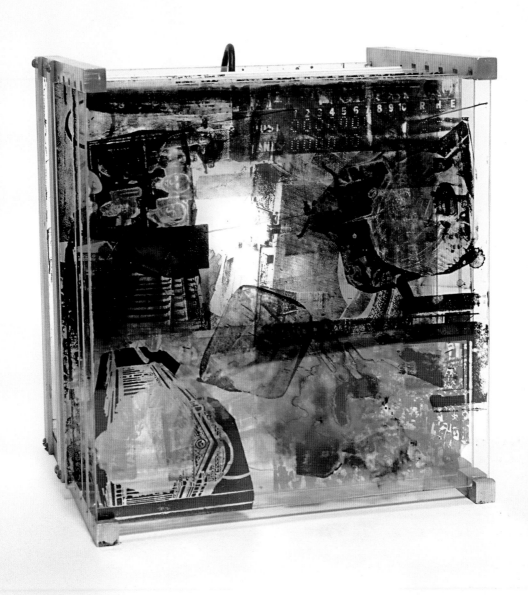

Robert Rauschenberg, **Shades**, 1964, six litographs printed on Plexiglas panels, mounted (five interchangeably) in slotted aluminium box on optional iron stand designed by artist, illuminated by a movable light bulb that blinks or burns steadily, 15.1 x 14.5 x 11.7 in. (38.4 x 36.8 x 29.9 cm), The Museum of Modern Art, New York

ANDY WARHOL
Brillo Boxes

Several Pop painters produced notable sculptures, but Warhol's *Brillo Boxes* are probably the best known. They were included in Warhol's second and final show at Eleanor Ward's Stable Gallery in New York, *The Personality of The Artist*. On the night of the opening, a long line waited outside to get in. The boxes were priced at two to four hundred dollars, depending on the size. Many collectors bought several; Robert and Ethel Scull bought twenty.

The *Times* art critic Grace Glueck reported, "'Is this an art gallery or Gristede's [supermarket] warehouse?' said a viewer when pop artist Andy Warhol's new show opened at the Stable Gallery April 21. Stacked from floor to ceiling were some 400 plywood grocery cartons, painted to resemble cardboard and bearing big-as-life replica trademarks—Brillo, Heinz Ketchup, Campbell's Tomato Juice, and so on. That was the show. As one observer said, 'Anti-Art with capital A's.'... When he heard about that, an abstract painter named Jim Harvey felt slightly (but not very) manqué. On the job for the industrial designing firm of Stuart & Gunn, where he is regularly employed, he had designed the *real* Brillo crate in 1961, and somehow

failed and still fails to see its potential. 'A good commercial design,' he says, 'but that's all.' What's more, his version is cheaper. Each cardboard carton, duly trademarked, costs the Brillo people between 10 and 15 cents."

The *Andy Warhol Catalogue Raisonné* notes that the show also included the box sculptures *Brillo (3¢ Off)*, *Mott's Apple Juice*, *Del Monte Peach Halves*, and *Kellogg's Cornflakes*.

Warhol began work on the idea of box sculptures in 1962—initially in cardboard. John Weber saw a prototype in November 1963 and thought them "sensational" for a show he was planning at Dwan Gallery in Los Angeles for early 1964. Warhol sent him one *Heinz Tomato Ketchup* and three *Brillo (3¢ Off)* boxes, all dated 1963.

Warhol produced the several hundred boxes with the help of Gerard Malanga—who had just moved into a new workspace with Warhol—and Billy Name, who decorated their studio in mirror, tinfoil, and paint, creating the Silver Factory. Havlicek Woodworking Company, Inc. made a truckload of pine boxes, which were laid out in a grid in the studio for silkscreening. Malanga recalled that the work took almost six weeks.

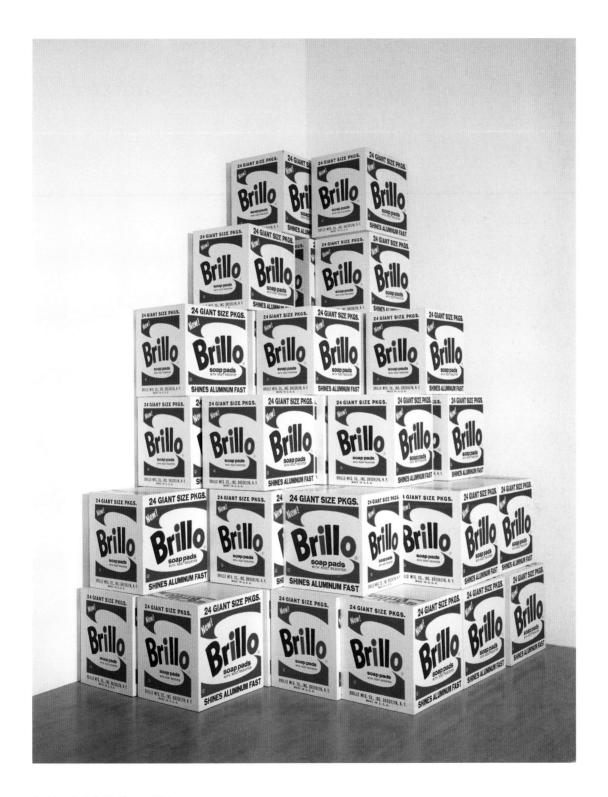

Andy Warhol, **Brillo Boxes**, 1964,
silkscreen ink on plywood, 45 boxes, each 20 x 20 x 17 in. (50.8 x
50.8 x 43.2 cm), Norton Simon Museum, Pasadena

JAMES ROSENQUIST
F-111

<div style="text-align: right">

1964–65

</div>

In the catalogue of James Rosenquist's 2003–04 retrospective, Thomas Krens, director of the Solomon R. Guggenheim Museum, summarizes Rosenquist's career: "As a commercial artist painting billboards in the 1950s, Rosenquist was witness to and absorbed the advertising media's powerful mechanisms of influence. Executing vast advertisements high above the crossroads of the world in Times Square, he learned firsthand how to distinguish the media from the message and how to frame the differences.... Through shifts in scale and content, Rosenquist reformulated photographs and advertising imagery from popular magazines into a kaleidoscope of compelling and enigmatic narratives on canvas.... Rosenquist's work has poignantly registered social and political concerns and reflected upon the dynamics of modern capitalist culture—an ongoing critique that reached its first zenith with the monumental *F-111* (1964–65). Superimposing images of consumer products, an underwater diver, a doll-faced child, and an atomic explosion along the fuselage of an F-111 bomber plane, the work illustrated the connection between America's booming postwar economy and what President Eisenhower characterized as the military-industrial complex."

F-111 was a wraparound site-specific work, designed to fill Leo Castelli Gallery for Rosenquist's first solo show there. It then toured Europe. *F-111* was interpreted as a powerful message for the peace movement. As Rosenquist explained in 1964, "the fragments or objects or real things are caustic to one another, and the title is also caustic to the fragments."

Recently *F-111* was reinstalled at MoMA as it was originally seen and intended. It consists of "fifty-one separate but interlocking pieces, as if it had been blown apart by the American fighter plane pictured on its surface and then reassembled." The simultaneity of the work, its four sides always beyond one's ability to apprehend all at once, is like a metaphor of the human subject in the modern world, immersed in a plethora of media events too many to absorb, overwhelmed by the enormity of the representations. Size does matter with Rosenquist. Today, standing in Time Square produces a similar effect, but now LED screens with moving images have replaced the billboards Rosenquist painted in the 1950s.

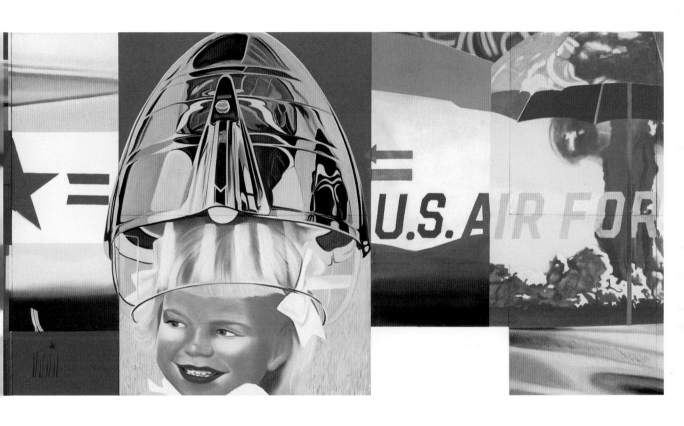

James Rosenquist, **F-111**, 1964–65,
oil on canvas and aluminium, 120 x 1032 in. (304.8 x 2621.3 cm),
The Museum of Modern Art, New York

CHRYSSA
The Gates to Times Square

1964–66

In Chryssa's mother tongue of Greek, *neon* means "new," and Chryssa's use of neon as art was a first, too. Born in Greece, Chryssa Vardea came to America at the age of twenty-one. Struck by what she called the "poetic" vulgarity of New York's Times Square, which turned the sky into a lighted ground "like the gold background of Byzantine mosaics of icons," she began *The Gates to Times Square* in 1964. The finished work is a ten-foot cube of welded stainless steel, cast aluminum, Plexiglas, and neon lights controlled by programmed timers, which integrate time into the work. Large, blue "A" letters form the ends of the work and doorways through which viewers can literally enter into the language of signs. Studies for parts of the work were sold individually, such as *Fragments for the Gates to Times Square II*, owned by New York's Whitney Museum of American Art.

The Gates to Times Square is Chryssa's masterpiece, hailed as one of the most important American sculptures. It is Pop in its embrace of a medium of mass advertising taken from everyday life and of modern technology as a source of new media.

The Gates to Times Square pushed the boundary of sculpture as three-dimensional object toward installation—the creation and occupation of space—and held considerable influence for later artists, including Yayoi Kusama.

One of the inventors of Pop Art, by 1961 Chryssa's reputation had already been established with a major solo exhibition at the Guggenheim. Chryssa began the repetitious printing—by stamping—of images such as ads for car tires (*Automobile Tires*, 1958–62) before Warhol. Critic Barbara Rose has remarked that Chryssa's *The Cycladic Books* (1955), made by casting plaster in a packaging box, predates American Minimalism by seventeen years—not to mention Rachel Whiteread. Like Jasper Johns, Chryssa's painting and sculptures of letters (e.g., *Unmailed Letter*, 1962) isolate and repeat alphabetic letters as art subjects, as well as such signs as that for the cent and the ampersand. Chryssa was included in MoMA's exhibition *Americans 1963*, curated by Dorothy Canning Miller, which helped cement the reputations of numerous Pop artists, including James Rosenquist, Claes Oldenburg, Marisol, and Robert Indiana.

Chryssa's cool detachment is also typically Pop. She left New York permanently for Athens in 1992.

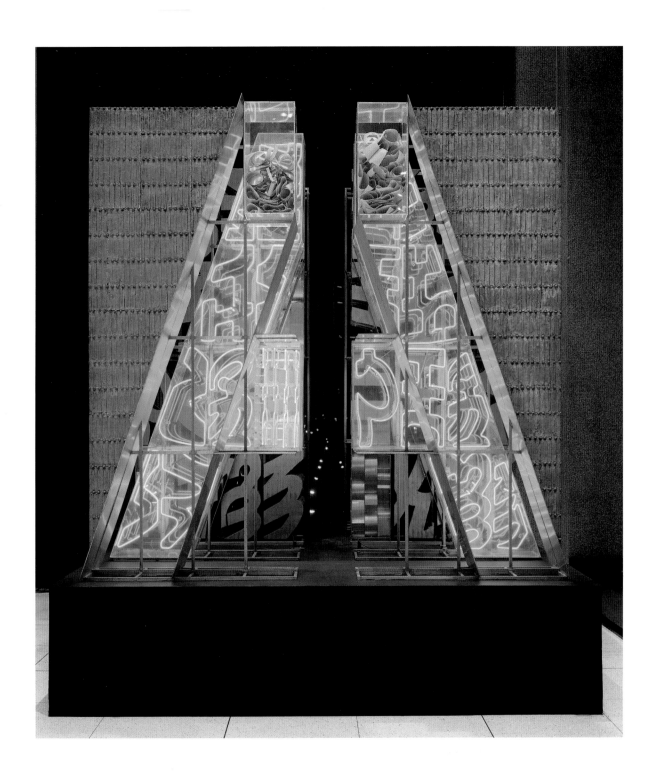

Chryssa, **The Gates to Times Square**, 1964–66,
welded stainless steel, neon and Plexiglas,
120 x 120 x 120 in. (304.8 x 304.8 x 304.8 cm),
Albright-Knox Art Gallery, Buffalo, New York

ANDY WARHOL
Silver Clouds

1966

Silver balloons would float about Andy Warhol's Silver Factory, decorated by Billy Name in silver paint, tinfoil, and mirrors. Warhol thought: "Silver was the future, it was spacey—the astronauts ... and silver was also the past—the Silver Screen.... And maybe more than anything else, silver was narcissism—mirrors were backed with silver." Even Andy's hair was silver.

In the Silver Factory, between 1964 and 1968, Andy shot movies and directed silkscreens and screen tests, while Warhol's superstars and hangers-on drifted in and dropped out. Silver, mirror mosaic, and tinfoil created the signature style of the speed-fueled sixties in Warhol's New York. This is remembered as the "Silver Era" not only because of the décor but also because of the decadence and dazzle of money, parties, drugs, and fame. Speed (amphetamines) staved off sleep and kept one slim—Andy took four diet pills a day in the early sixties, after seeing himself in a magazine looking fat. Andy said his schedule was to work till midnight, go out on the town, get home around four, take a Seconal around dawn to sleep, and then get up after a couple of hours. "Andy Warhol, Silver Screen, Can't tell them apart at all. Andy walking, Andy tired, Andy take a little snooze"—went the words of a song by David Bowie, a visitor to the Silver Factory.

Andy asked Billy Klüver, an electrical engineer and collaborator with Pop artists, to help him make a floating light bulb. It proved impossible, but they came across Scotchpak; made by 3M for the army to wrap sandwiches, it is impermeable to helium and easy to seal. Warhol said, "Let's make clouds." *Silver Clouds* filled Leo Castelli Gallery in April 1966. Superstar Willard Maas' four-minute film—complete with tinfoil titles—captures the atmosphere of the night and the Silver Era. The helium-filled clouds circulated randomly among the enchanted crowd, touching and inviting touch, like living beings, floating, while some pillows filled with mere air remained grounded. Choreographer Merce Cunningham created a peace called *RainForest* (1968) around them, with costumes by Jasper Johns.

Today, the version installed at the Andy Warhol Museum in Pittsburgh remains a perennial favorite with visitors—especially children—who can activate and engage with the work, filling the space.

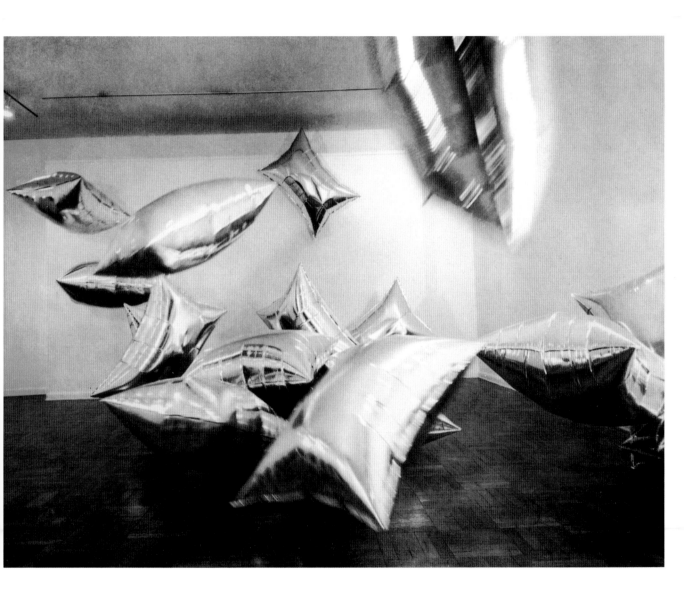

Andy Warhol, **Silver Clouds**, 1966,
helium-filled metalized plastic film, installation
in Leo Castelli Gallery, New York

DEREK BOSHIER
SexWarSexCarsSex

<div align="right">1966</div>

The 1961 *Young Contemporaries* exhibition established Peter Blake, Derek Boshier, David Hockney, Allen Jones, and Peter Phillips as part of a new trend. Curator John Russell wrote in the introduction to the catalogue of the 1969 *Pop Art Redefined* exhibition at the Haywood Gallery, "Royal College Pop was free-wheeling and hedonistic ... a contribution to the idea of an England at last recovered from the lethargy of the post-war period. English Pop was painterly, anecdotal, diffuse, jokey, deliberately unfocused: all things which delighted a public that has enough of low-spirited English representational painting."

Influenced by Marshall McLuhan, Boshier's work commented on such issues as the space race, the influence of corporations and Americanization on English culture, and apartheid.

Boshier collaborated with poet Christopher Hogue on *SexWarSexCarsSex*. The central "SEX" in the title is overprinted with "Cleanliness is Next to Godliness." This renders the opening words, stating that a body was sold for a bar of soap, ironic: cleanliness led to sin. Boshier's pseudo-moralistic framework echoes the "confessions" in Eduardo Paolozzi's *I was a Rich Man's Plaything*.

Boshier's work, like Paolozzi's, references war, but Boshier points out that America's warring in Asia boosts luxury car production. He links car culture and gun culture, and sex and death. His third frame asks: "All my buddies say they get erections when they kill, but why don't I?" These themes persist in Boshier's work—and in reality. In America today, television ads for erection boosters and testosterone supplements vie with gun massacres of innocents by deflated perpetrators. Boshier's 2004 installation *99 Cent War*, an indictment of the Gulf War created with cheap war toys, was acclaimed in America, where Boshier now works. The Iraq war killed over 100,000 civilians, thousands of combatants, and cost trillions; but Haliburton/KBR—the corporation led until 2000 by Vice President Cheney, who pushed for war on false premises—earned billions. President Eisenhower's warning against the corrupting influence of the military-industry complex remains prescient.

The "popular culture" that most Pop Art blandly endorses is consumerism, fueled by corporations via mass marketing. Boshier appeals to popular opinion; his critique on behalf of the masses is rare in Pop Art.

SEX WAR SEX CARS SEX

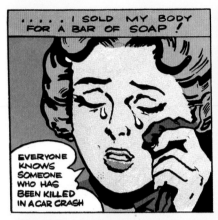

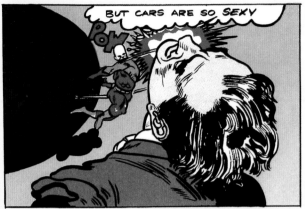

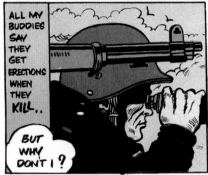

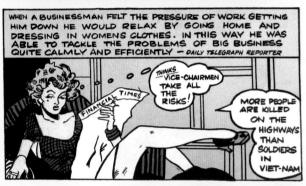

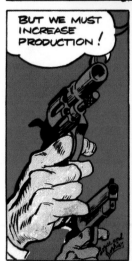

Derek Boshier, **SexWarSexCarsSex**, 1966,
screenprint on paper, 22.8 x 17.5 in. (58 x 44.5 cm)

EVELYNE AXELL
Erotomobile

1966

Evelyne Axell's *Erotomobile* subverts many strategies of male Pop artists. Her bleached women contrast with Ramos's fleshy, Playboy pinup-like women coyly inviting the male gaze while presenting a commodity (pp. 116/117). Axell shows no breasts here; rather than nude—undressed to be looked at—these are naked women. Unlike Wesselmann's red lips and red nipples, excised and eroticized, the redness in this work is from a painted car tire Axell has attached from the much-fetishized car. Like a target, it circumscribes the women gazing into each other's eyes—suggesting either the autoeroticism of a mirror image or lesbian desire. The tire highlights the woman/women instead of the woman sexualizing the car. This reverses the current of mass marketing, rather than endorsing and underscoring it.

Axell, born and based in Belgium, not only adopted her gender-neutral name, but appropriated desiring and controlling positions usually reserved for men in the dominant culture of the day. Playing on the word "acceleration" and underscoring her self-naming, her painting *Axell-ération* of 1965 shows only a woman's high-heeled red shoes in the well of a driver's position, pushing the pedal to the metal. This image of liberation was echoed later in works that supported the protests of 1968 and of the sexual revolution in general.

Axell's official website clarifies how her work unfolded in the context of a global consciousness, a "planetary existential model: Pop Art was at the centre of a socio-cultural constellation alongside pop songs, pop music, hamburgers, jeans and popcorn.... [French New Realist artist] Niki de Saint-Phalle was celebrating triumphant feminism with her generously curved women, César was switching from compressions of cars to polyurethane expansions, Warhol was making infinite reproductions of screen-printed portraits of stars."

The relationships to Pop of New Realism in France and of Capitalist Realism in Germany (an ironic label for Pop, contrasting America's consumerist art with Soviet Socialist Realism) are topics too complex for this book, but the flatness of Axell's painting technique and her embrace of new materials, especially plastics and car paint, show more affinity with American Pop than do most European artists. Like Pauline Boty in the UK, Axell died tragically young, truncating her work and its reception.

Evelyne Axell, **Erotomobile**, 1966,
oil on canvas and car tire, 59.1 x 59.1 in. (150 x 150 cm),
Musée d'Ixelles, Ixelles

JANN HAWORTH
Maid

1966

Jann Haworth is a pioneer of soft sculpture, both representational and oversized—along with Claes Oldenburg, Patty (Mucha) Oldenburg, and Yayoi Kusama. Haworth also co-created one of the most famous images of popular culture—the cover for the Beatles' *Sgt. Pepper's Lonely Hearts Club Band* album—with Peter Blake, her husband. Included among the crowd in the cover design are Haworth's soft sculptures of an old lady and Shirley Temple.

The daughter of distinguished artist Miriam Haworth and Ted Haworth, the Oscar-winning art director of such notable Hollywood movies as *Invasion of the Body Snatchers* (1956), the Marilyn Monroe vehicle *Some Like It Hot* (1959), and *The Longest Day* (1962), Jann Haworth grew up understanding art and artifice, props and illusions.

As a Slade student, Haworth chose materials she knew her male peers couldn't handle, and pioneered soft sculptures in 1962. She also made quilts of the *Los Angeles Times* that included comics (1962–63)—a quintessentially Pop subject. However, it was her painting of a typewriter—that icon of female employ-ment—that was accepted into the 1963 *Young Contemporaries* exhibition, and

sold, which launched her career. The trendy gallerist Robert Fraser noticed her work at the ICA's 1963 exhibition *Four Young Artists*, and gave her a solo show.

Fraser was part of the "in" set of Swinging Sixties London, a friend of the Beatles and the Stones, and he recom-mended Haworth and her then-boyfriend Peter Blake to design their famous album cover.

Commissioned to create a soft-sculpture Playboy bunny for Hugh Hefner's birthday, Haworth canceled the contract and converted the piece into an image of a mixed-race working girl, *The Maid*. Uniformed in a miniskirt and lacy apron with a heart-shaped bib, the subservient maid seems to serve male fantasies, but her sutured seams bespeak her artificial nature. She is a construction—like a blow-up sex doll or a Frankenstein-like reconstruction of body parts. *The Maid* points, too, to issues of race, class, and power. "The base of my work is film and time-sequence, therefore the images I was creating in London, which were all American images of Mae West or a cowboy or a surfer or a maid—they were all American images, and they were called Pop."

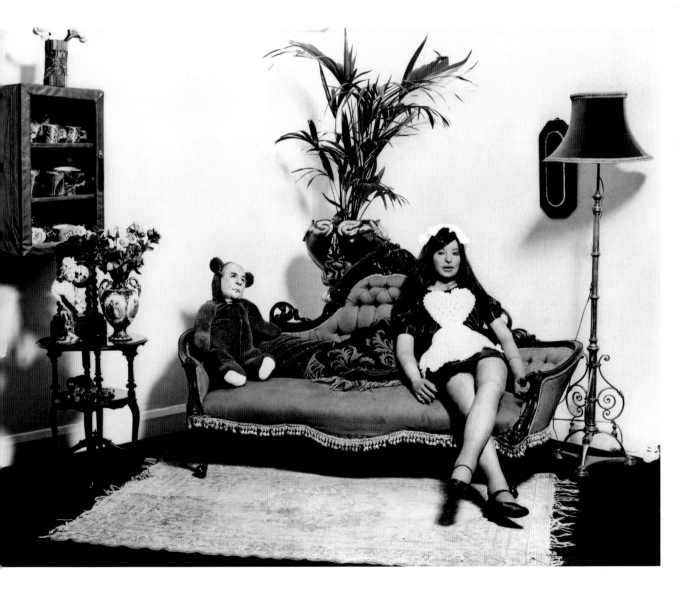

Jann Haworth, **Maid**, 1966,
nylon, cotton, satin, kapok, human hair, plastic, paint, wood, chair,
floor lamp, overall installed 43 x 38 x 58 in. (109.2 x 96.5 x 147.3 cm),
Walker Art Center, Minneapolis

ROSALYN DREXLER
Is It True What They Say About Dixie?

1966

Rosalyn Drexler's flash-frozen figures mobilize a heady mix of associations. Her title is that of a popular song, released by early rockers Bill Haley and the Comets in 1957, that romanticizes the South—where America's ugly struggles for Civil Rights were playing out. Drexler adapted her image from a photograph of a posse of white supremacists following the notorious police chief Bull Connor, whose actions provoked the 1963 Birmingham Race Riots. When Drexler's painting debuted, her title would have evoked Dean Martin's version of this song, crooning the line "Is the dream by that stream so sublime?" Dean Martin—along with Frank Sinatra and the African-American singer Sammy Davis, Jr.—headed the Rat Pack, a circle of singers, film stars, and celebrities who lit up Las Vegas marquees, attracting high rollers who filled the coffers of the casinos linked to organized crime. President John F. Kennedy's brother-in-law, Peter Lawford, was in the Rat Pack; Marilyn Monroe was one of its "mascots."

Guns, gangsters, and G-men pepper Drexler's paintings. They point to the undertow beneath the surface of the American Dream. In her *Marilyn Pursued by Death* (1967), a suited figure dogs the diva, suggesting specters of subterfuge behind her suicide, and perhaps even the assassination of JFK, her lover: Did they do or know too much or too little for the shadowy forces to let them live? The foreboding in this and other Drexler works foreshadows the assassinations of Martin Luther King, Jr. (April 4, 1968) and Bobby Kennedy (June 5, 1968), preceded by the attempted slaying of Andy Warhol on June 3 by radical feminist Valerie Solanas.

Hand in hand with struggles for Civil Rights, the struggles of feminism color Drexler's life and works. Solanas was the radical lesbian founder/head—and apparently sole member—of the Society for Cutting Up Men (SCUM). Solanas rejected mainstream liberal feminism as "a civil disobedience luncheon club" that adhered to the cultural codes of feminine politeness and decorum, which were the source of women's debased social status.

Though Solanas was deranged, her shooting of Warhol highlights gender frustrations that many women—including artists like Drexler—experienced during the Pop era. Although Drexler was widely shown and favorably reviewed, she never matched the acclaim her male peers achieved.

Rosalyn Drexler, **Is It True What They Say About Dixie?**, 1966,
oil and paper collage on canvas, 60 x 84 in. (152.4 x 213.4 cm),
The artist's collection

MARTHA ROSLER
Body Beautiful, or Beauty Knows No Pain:
Woman with Vacuum: Vacuuming Pop Art

In the catalogue for the influential exhibition *Seductive Subversion: Women Pop Artists, 1958–1968*, Rosler speaks for herself. She points out that the post-World War II era entailed "a democratic reconstitution of the West as a space friendly to the private peace of the gender-bipolar nuclear family, as against the earlier possibility of a society split by class war." In Pop Art, the figure of the woman was attached to the home and to the manufactured desire for commodities. "In both locales she is the masquerade of faceless capital whose origin is in the boardroom but which is projected into the home, in a maneuver that every modern man knows about."

In this collage the domestic apparatus wraps around the smiling wife pinned to the heart of the home. Rosler asks, "The ambiguity of gender as power in pop reflects the ambiguity of possession: in gaining commodities, who has mastered what?" The winners here are the maker of the vacuum and the media that market it to the masses, allies in a broader trend to territorialize the disempowered woman into the nest of the perpetually threatened nuclear family. "In the West, the engineering of personal desire and political consent shadowed all of social life with the twin specters of Eros and Thanatos, sex and the Bomb."

Rosler's housewife cleans a tight passage hung with a mirror, Duchamp and Robert Indiana posters, and a Kiki Kogelnik-like image of a post-pill liberated woman. Whatever the cultural implications of Dada and Pop, she is home, cleaning, beautiful, uncomplaining, feeling no pain. This collage invites comparison with Richard Hamilton's 1954 work (pp.30/31), and with Dadaists like Hannah Höch. In another Rosler work, *Cleaning the Drapes*, Vacuum Woman draws aside a curtain to reveal a scene of the Vietnam War "outside." Rosler's collages, begun in 1964–65, were not signed or dated but duplicated and distributed as "agitational flyers" during protests. Later, in the wake of Rosler's impressive career as a public intellectual, they were reappraised as art objects.

Rosler made explicit what Pop Art often left implicit: "If pop contains a critique, it depends on the viewer to perceive it, and many could not. Instead, many—especially the new postwar petite bourgeoisie—saw affirmation and confirmation in its bright accessibility and fun. Critique, like women's voice, is absent, appears as absence."

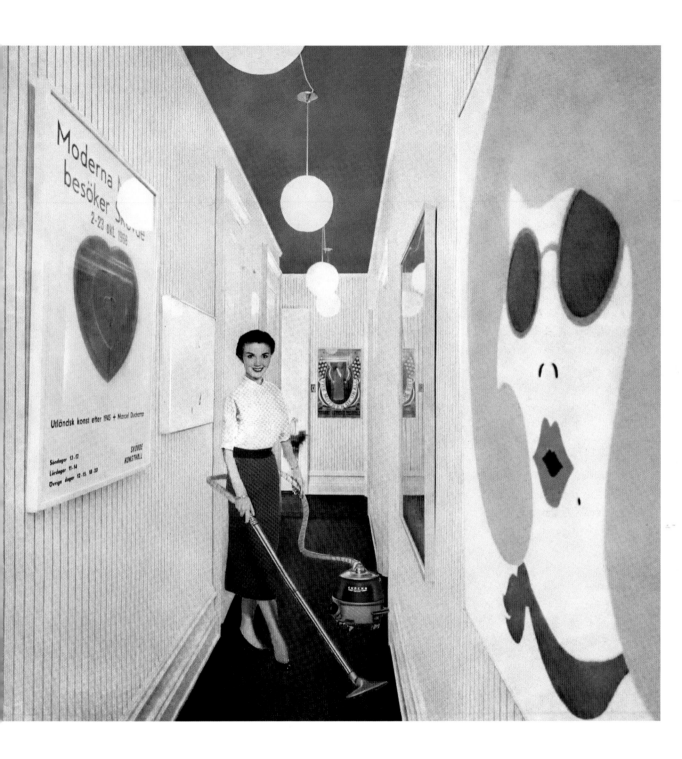

Martha Rosler, **Body Beautiful, or Beauty Knows No Pain:**
Woman with Vacuum: Vacuuming Pop Art, 1966–72,
photomontage, C-print

ALLAN KAPROW
Fluids

1967 (2008)

In 1957, George Brecht took Allan Kaprow on a mushroom hunt led by expert John Cage. Kaprow had collaged into his own paintings diverse materials and movable parts for viewers to activate, and discussed with Cage problems he faced with musical elements of his "action collages." He began to attend Cage's experimental music classes in New York, along with George Segal and Robert Watts. They were all colleagues at Rutgers University in New Jersey, along with such other pioneers of Pop and Fluxus as Lucas Samaras and Roy Lichtenstein. Cage's Zen- and Dada-influenced focus on the role of chance in creativity proved inspirational.

Kaprow coined the term "happening" in 1957 to mean "something spontaneous, something that just happens to happen." The term appeared in print in late 1958. Kaprow's *18 Happenings in 8 Parts*, regarded as the first happening, took place on October 4, 1959, with seventy-five invited guests, inaugurating the Reuben Gallery in New York's East Village. The audience was given instructions that made them participants in a tightly scripted event. They had to change seats or move between the three installation rooms, while the cast, including Cage and Robert Rauschenberg, performed such actions as bouncing a ball and squeezing oranges.

For Kaprow, a happening fused art and life; he "integrated his art into his everyday life through his teaching activities and his Happenings were primarily created with the students he taught." Kaprow stopped staging happenings in New York City in 1963, when art dealers and out-of-towners started to arrive by limousine. "Happening" went mainstream: something cool could be called "happening"; people greeted each other with "what's happening?"; the Supremes used it in a song title; it even crept into ad campaigns.

Kaprow's 1967 retrospective in Pasadena, California, included his happening *Fluids*. A rectangular enclosure, solidly walled with ice blocks, was left to melt over three days. Kaprow originally intended "about twenty" enclosures. In April 2008, ten were recreated in California venues, including the Getty Center in Los Angeles. There, the LA Art Girls recreated *Fluids* as an all-women's activity, highlighting the fact that suriving photos of the 1967 *Fluids* show only men lifting blocks, although women had also participated.

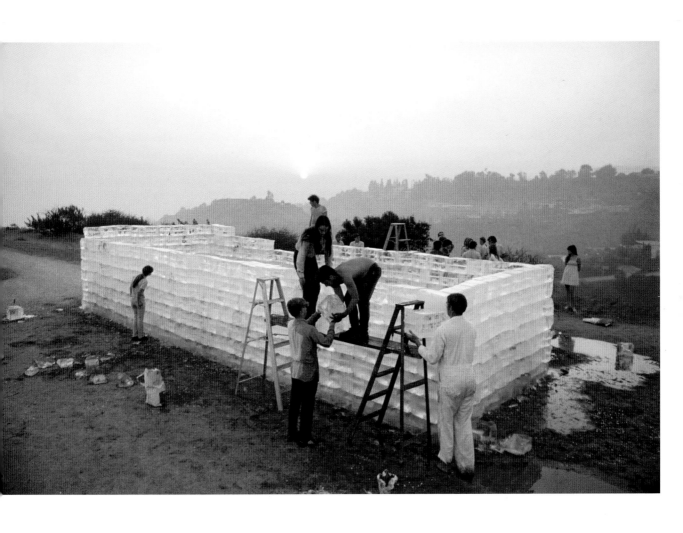

Allan Kaprow, **Fluids**, 1967 (2008),
rectangular enclosure of ice blocks, 360 x 120 x 96 in.
(914.4 x 304.8 x 243.8 cm), happening in Pasadena, California

DAVID HOCKNEY
A Bigger Splash

David Hockney's career has made the biggest splash of all the British Pop artists—and *A Bigger Splash* is his best known work. Its arresting motif is the splash, frozen in time, implying action, and an actor, who is invisible, underwater. The crisp light and lines of the modern house and towering palms, all framed square and with a thick white border, suggest an oversized Polaroid photograph of an everyday moment in California, where David Hockney was teaching. Few snapshots, though, are as carefully structured as Hockney's gridded composition of flat planes and strong perpendiculars, enlivened by the directional diagonal of the diving board. Hockney reveled in taking two weeks to paint a splash that had lasted but an instant, while the more permanent buildings were easily painted flat with rollers, using fast-drying acrylics, which he discovered in California.

A Bigger Splash is based on a photograph of a pool and a Hockney drawing of buildings. Through much of his career, he has been fascinated by how photographs distill and distort time and reality. His "joiner" works—multiple photographs, with slightly shifted viewpoints, of the same subject—are important contributions to art photography.

Several Hockney paintings akin to *A Bigger Splash* replicate photos of the ripples and reflections on the surfaces of pools, which, like the splash, become abstracted. Often, naked men glide underwater or doze poolside, suggesting that sun-kissed sex is a significant part of this life of leisure. It is far removed from the depressed and repressed atmosphere of postwar Britain. The first generation of British Pop artists imagined America as a place of plenty and envisaged a brighter future. Their students, like Hockney, were able to live it.

Even in his student work, Hockney had referenced his homosexuality. He painted two men showering together in *Domestic Scene, Los Angeles* (1963), inspired by *Physique Pictorial*, a California-based beefcake magazine, before the first of his many visits to L. A., where he lived for long stretches. He found the sexy California of his imagining enlivened by an intellectual circle that included British writer Christopher Isherwood, whose *A Single Man* of 1964 was a founding text of the modern gay movement. Jack Hazan's 1975 award-winning film *A Bigger Splash* documents Hockney's life and work amid this L. A. milieu.

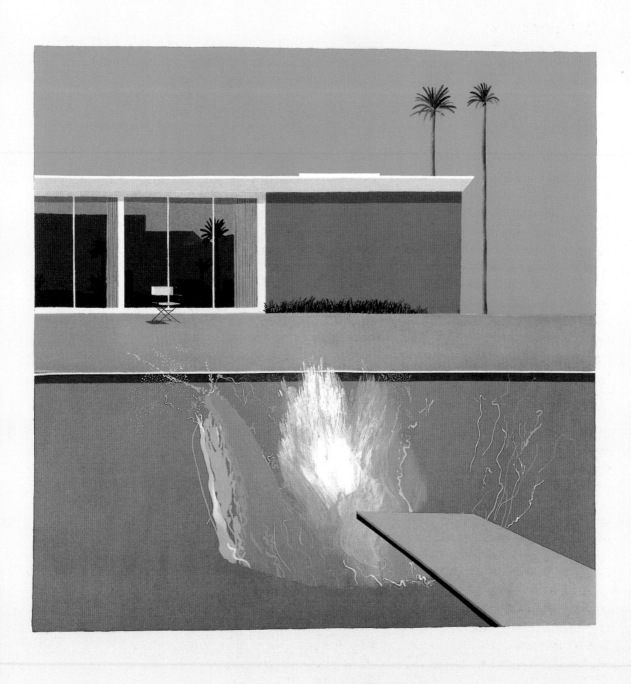

David Hockney, **A Bigger Splash**, 1967,
acrylic on canvas, 95.5 x 96 in. (242.5 x 243.9 cm), Tate, London

PETER BLAKE (WITH JANN HAWORTH)
Sgt. Pepper's Lonely Hearts Club Band record cover design

1967

Peter Blake was a Pop pioneer in the Independent Group. He painted comics (1954), images of Marilyn (1959) and Elvis (1960–61), and even a gold series (1959)— before Andy Warhol. His matchbox sculpture predated Warhol's boxes; his multiple object *Babe Rainbow* (1968) was an edition of 10,000. When Blake came to New York to show in the Sidney Janis Gallery's *International Exhibition of the New Realists* (1962), he says Warhol "pretended he didn't know my work, but he must have done." Blake was aware of Rauschenberg and Johns in the 1950s and painted *The First Real Target* (1961) to be less painterly than Johns's. The New York critics were so vicious that Blake vowed never to show there again, and his breakthroughs were overlooked.

Blake wanted "to make an art that was the visual equivalent of pop music. When I made a portrait of Elvis I was hoping for an audience of sixteen-year-old girl Elvis fans, although that never really worked." Blake only achieved a pop-music audience of millions with his album cover design—yet even this must be shared, with his then wife Jann Haworth. "I'm the person who didn't do 50 percent of the *Sgt. Pepper* cover," she says with irony, "I did the other 50 percent." When Haworth applied to the Slade School of Art in London in the early sixties, she was told "the girls were there to keep the boys happy." Tutors didn't review the application "portfolios of the female students ... they just needed to look at their photos." Haworth staged the cover like a set. Among the array of heroes, whom the Beatles were meant to select (both Blake's ideas), are Haworth's soft-sculptures of an old woman and Shirley Temple.

Blake never took drugs, but LSD's entry into the London scene in 1965 transformed creative circles. In January 1967, hippies convened for the Human Be-In at San Francisco's Golden Gate Park, where Timothy Leary quoted communications guru Marshall McLuhan's mantra: "Turn On, Tune In, Drop Out." Shortly after *Sgt. Pepper's* release, the three-day Monterey International Pop Music Festival—the first major rock festival—kicked off California's legendary Summer of Love, when more than 100,000 people converged on Haight-Ashbury, beginning the flower-power hippie revolution. *Sgt. Pepper's Lonely Hearts Club Band* flavored that summer—its psychedelics revolutionized popular music worldwide.

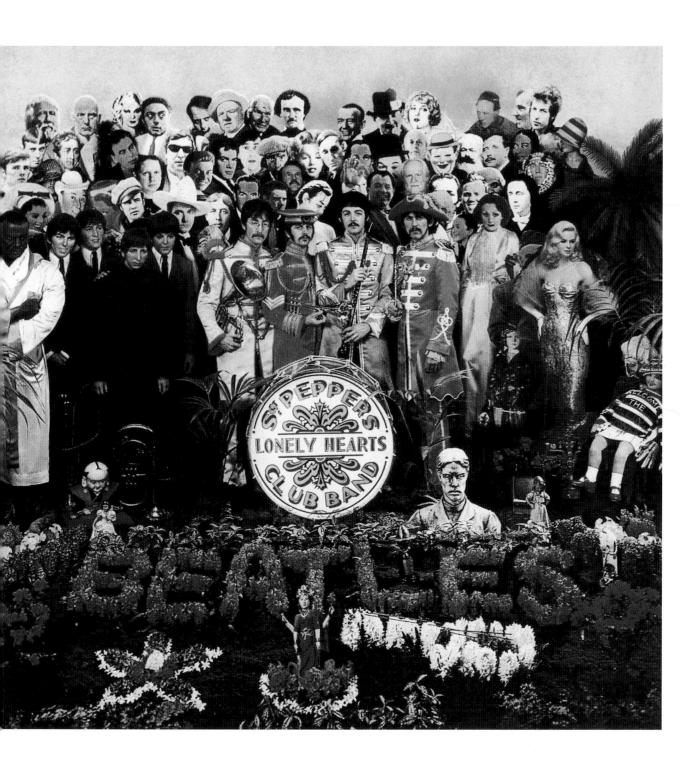

Peter Blake (with Jann Haworth), **Sgt. Pepper's Lonely
Hearts Club Band record cover design**, 1967,
color offset lithograph on paper and card, 12.2 x 12.2 in.
(31.4 x 31.4 cm), private collection

ANDY WARHOL
The Velvet Underground & Nico

For Andy Warhol, Pop meant anybody could do anything. That included all aspects of the music business. Warhol's 1966–67 *Exploding Plastic Inevitable* created a template for the multimedia rock concert. It combined innovative lighting, projected 16 mm films (Warhol's own) and colors, and the challenging music of the Velvet Underground, managed by Warhol and fronted by Lou Reed. Warhol encouraged the band to use the beautiful Nico as a singer, and the stage spectacle was enhanced by performances by Gerard Malanga, who did an S&M whip dance, with other Warhol Superstars, such as Edie Sedgwick and Ingrid Superstar, dancing alongside.

Exploding Plastic Inevitable epitomized the New York subculture of Warhol's Silver Factory—quite unlike the West Coast hippie scene, with its emphasis on peace, love, LSD, and marijuana. As Stephen Koch remarks in *Stargazer* (2000), the Silver Factory "was crowded with a-heads [or A-men, amphetamine users], street geniuses, poor little rich girls, the very chic, the desperately unknown, hustlers and call boys, prostitutes, ... the best artists of the time, and the worst hangers-on. The people 'in' thought the place was everything: intensity without demands, class without snobbery, glamour without trying. Not to mention a lot of sex, a lot of art, a lot of amphetamines, a lot of fame. And a door that was always open." There were also curators, collectors, Harvard students, transvestites, socialites, and working-class gay men: "a thrilling complicity united the artistic and sexual and drug subcultures."

Warhol designed this cover for the 1967 debut album of the Velvet Underground and Nico, which was recorded during Andy Warhol's *Exploding Plastic Inevitable* multimedia tour in 1966. Above the yellow banana was the instruction "Peel slowly and see." Peeling back the skin over the banana revealed a fleshy pink interior. In 2003, *Rolling Stone* magazine hailed this as the "most prophetic rock album every made," and the thirteenth greatest album of all time.

During the 1970s, Glam rock exaggerated features of the *Exploding Plastic Inevitable*, especially the staging of alternative or transgressive sexuality, which became incorporated into popular culture through such characters as the superstar Ziggy Stardust, David Bowie's alter ego.

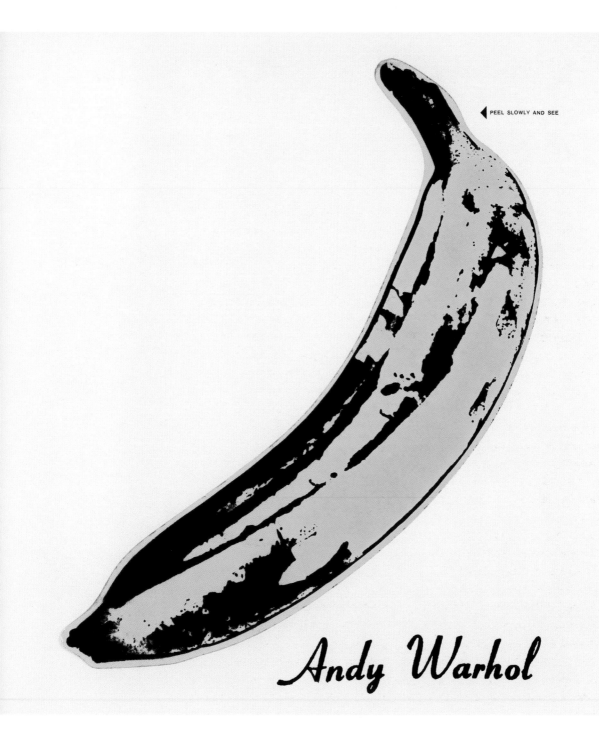

PEEL SLOWLY AND SEE

Andy Warhol, **The Velvet Underground & Nico**, 1967,
record cover design

CHRISTA DICHGANS
Stilleben mit Grünem Vogel (Still Life with Green Bird)

1968

Living with Pop—A Demonstration for Capitalist Realism. This was the title of Berlin gallerist René Block's 1963 happening and the exhibition organized by Gerhard Richter and Konrad Lueg in Düsseldorf. "Capitalist Realism" conveyed and conditioned German reception of the Pop Art movements then gathering steam in London and New York. When Christa Dichgans found herself "living with Pop" in New York in 1966 as a young mother on a DAAD scholarship and a tight budget, the used toys in thrift stores became her subjects. She paints them in piled heaps, heightening the sense that they are the discarded surplus of capitalist plenty and of innocence outgrown. Arrested in uncanny arrangements—in a 1967 work we see a blow-up Batman astride an inflatable stars-and-stripes catfish—they suggest both Dichgans's deliberate ordering and the chance, obscene arrangement of bodies and objects after a tsunami.

In *Still Life with Green Bird*, three inflatables intertwine, fish, fowl, and seahorse, surmounted by a lobster inverted. They form a heraldic emblem of chaos for 1968, when Western youth rebelled. The high degree of realism and surface detail in these toy paintings, as well as their vivid colors, flat lighting, and often-square formats, are reminiscent of Polaroid photographs.

Also in 1968, Dichgans began to isolate into Pop icons such objects as the eponymous *Papierflieger* (Paper Jet), *Zitronenpresse* (Citrus Squeezer), and *Ball*. Her paintings of inflatables include a Magritte-like white plastic cloud against a blue sky, a black thundercloud with yellow lightning bolt, *Flipper*, *Clown*, and *Snow White*, all of 1969, as well as an inflatable heart, *Plastikherz* of 1970. Dichgans also painted rhythmically duplicated inflatables, as in *Grüne Enten* (Green Ducks) and *Wolken* (Clouds) of 1968. These inflatables presage the sculptures of inflatable toys Jeff Koons produced from the eighties onward.

The unease in Dichgans Pop Art works becomes, in *Ausschnitt aus New York* (Cutout from New York) of 1980, an awful premonition of an attack. One wing of a giant airplane is visible as an immense Lichtenstein-style fireball engulfs the World Trade Center. Punctuating the foreground are a pencil, a suitcase, a canned product with the words "VAPOR" and "DEAD" on the label, and an Islamic banner.

Christa Dichgans, **Stilleben mit Grünem Vogel**
(Still Life with Green Bird), 1968,
aquatec on canvas, 39.4 x 33.5 in. (100 x 85 cm),
private collection

MAY STEVENS
Big Daddy Paper Doll

May Stevens's trenchant 1968 image links the faces of violence and oppression with patriarchy, which begins at home, with dad and his loving lapdog bulldog. Stevens's *Big Daddy* series connects her anger toward the Vietnam War with that toward her father.

To Stevens, her staunchly patriotic father represented "a closed attitude toward the world. It was a middle-American attitude towards culture, towards politics, towards Black people, and towards Jews. He was a person who had stopped thinking when he was twenty and hadn't opened his mind to anything since."

Big Daddy is "watching the world go by, the world for which he is responsible, and his expression does not change. Wars against defenseless villagers, the oppression of women, racist murders, economic discrimination against more than half the world, children not allowed in schools," so critic Lucy Lippard responded in 1975 to the image of Big Daddy.

Stevens's image suggests that dad-at-home, with his beloved pet, easily takes on other roles: dad as an agent of Big Brother becomes Big Daddy, the face of patriarchy. Dad is the soldier decorated for killing in the name of country—and in 1968 that pointed the finger at the Vietnam War, widely regarded as unjust, brutal, and often criminal. Dad is the policeman—in sixties parlance that means the "pig"—who preserves patriarchy's "order" even when it means using violence against citizens exercising their democratic rights to protest for peace and equal rights. Dad at the barbecue becomes Dad the Klansman or executioner, the butcher, with blood on his hands.

If one can see through that kind of Dad, perhaps he can be viewed as a paper tiger: disarmed or disrobed, he's just a blathering lapdog.

Like many Pop artists, May Stevens makes an object of popular culture the subject of her work, but here she has transformed the popular toy into a sinister and ironic object. Her paper doll—unlike the plastic, idealized Barbie, pretty, perfect, and pure—presents a violent picture of a patriarchal culture. Take your pick, it seems to say, every interchangeable costume invites critique: no matter how you dress it up, the core remains the same. Play with any doll long enough and its values could rub off on you.

May Stevens, **Big Daddy Paper Doll**, 1968,
acrylic on canvas, 60 x 108 in. (152.4 x 274.3 cm),
Ryan Lee Gallery, New York

TOM WESSELMANN
Great American Nude #99

1968

Tom Wesselmann attributes his subject matter—and therein lies his fame—to a dream. Like Jasper Johns's dream (p.32), Wesselmann's had a patriotic theme: he dreamed the words "red, white, and blue." He "decided to paint a *Great American Nude* in a palette limited to those colors and any colors associated with patriotic motifs such as gold and khaki. The series incorporated representational images with an accordingly patriotic theme, such as American landscape photos and portraits of founding fathers. Often these images were collaged from magazines and discarded posters, which called for a larger format than Wesselmann had used previously. As works began to approach a giant scale he approached advertisers directly to acquire billboards." This quote from the Wikipedia entry on Wesselmann credits as its source Slim Stealingworth, a pseudonym under which Wesselmann wrote a book about his own work to boost recognition. "Many critics have described Tom Wesselmann as the most underrated painter of the American Art world of the 1960s," said Slim Stealingworth in 1980!

Wesselmann's nudes became formulaic, and like Mel Ramos's nudes, it is not so much one particular work that

commands recognition, but the recipe. The *Great American Nude* series (1961–73) ran up to #100. Number *99* has the virtue of reflecting a mature stage of the series. The main ingredients—bright red lips balanced by red nipples, bright, untanned breasts against a cobalt sky, and a column of white smoke—are all in place.

Wesselmann's "fleshscapes" are not without wit. Wesselmann plays with a high degree of abstraction and toys with the flatness of his planes against the illusion of depth. In *#99*, a dark cushion pushes up into the image like a collaged fragment. It asserts the flat surface, structures the work formally, and points the viewer's gaze toward the ashtray in the background, where the cigarette burns away, introducing time into the picture—and mortality. Those cigarettes, advertised as part of the good life, the leisure-time reward in the jingle "after-action satisfaction," kill. Death stalks sex.

Wesselmann participated reluctantly in the landmark *New Realists* show at the Sidney Janis Gallery in 1962, but disavowed the Pop label. His formal concerns were also explored in new materials, such as Plexiglas, and later in metal reliefs and sculptures.

Tom Wesselmann, **Great American Nude #99**, 1968,
oil on canvas, 59.8 x 81.1 in. (152 x 206 cm),
Morton G. Neumann Collection, Chicago

YAYOI KUSAMA

The Anatomic Explosion Happening, at the Alice in Wonder-
land sculpture (Naked Happening in Central Park)

1968

Abused by her mother, Yayoi Kusama drew obsessively, in secret. Today she lives in a home for the mentally ill, still processing her past, but says that art therapy is all she needs, so she keeps creating compulsively, often reworking hallucinations and dreams.

Kusama has always shown courage. In 1957, speaking no English, she burned thousands of her artworks and set off for America to make a new kind of art. She wrote to Georgia O'Keeffe, who tried to dissuade her from coming, but helped her to sell work when she arrived. Her first buyer was Donald Judd, then a student writer. They were close.

Kusama recalls producing about a hundred paintings and drawings daily in the early sixties. Her "net paintings" generated patterns that evolved to cover her studio and her body. This led, in 1962, to her soft sculptures of phalluses that covered environments: the *Sex Obsession* works. They exorcised the fear of sex she grew up with, but even when she reclined in a sea of silver phalluses, nude but for her high heels, she still reviled herself.

In her 1967 prizewinning film *Kusama's Self-Obliteration*, polka dots painted on various things dissolve them and merge them with other things—a

painting and the pond it floats in, a rider and her horse. "We are all dots," she says, "the stars are dots. I paint polka dots on the bodies of people so that people will self-obliterate and return to the nature of the infinite universe." Her kaleidoscopic *Infinity Mirror Room* installations (beginning in 1965) fragment identity to the point of disappearance. At one of her *Naked Happenings*, staged under black light at the Village Gate, only the fluorescent dots on participants' flesh flickered; their bodies became invisible. She exhorted, "Obliterate your personality with polka dots; become one with eternity; become part of your environment; take off your clothes, forget yourself." Part of Kusama's antiwar "Love Forever" philosophy, other *Naked Happenings* happened on Wall Street, in front of the Statue of Liberty, and on the Brooklyn Bridge. She staged anti-Nixon protests at a polling center and at the Internal Revenue Service, and an antiwar performance in front of the UN.

For the *Alice in Wonderland* happening, Kusama says, "Each of us wore makeup, impersonating Lyndon Johnson, Che, Castro, Marilyn," with Kusama as the modern Alice in Wonderland.

Today, Kusama disavows Pop Art.

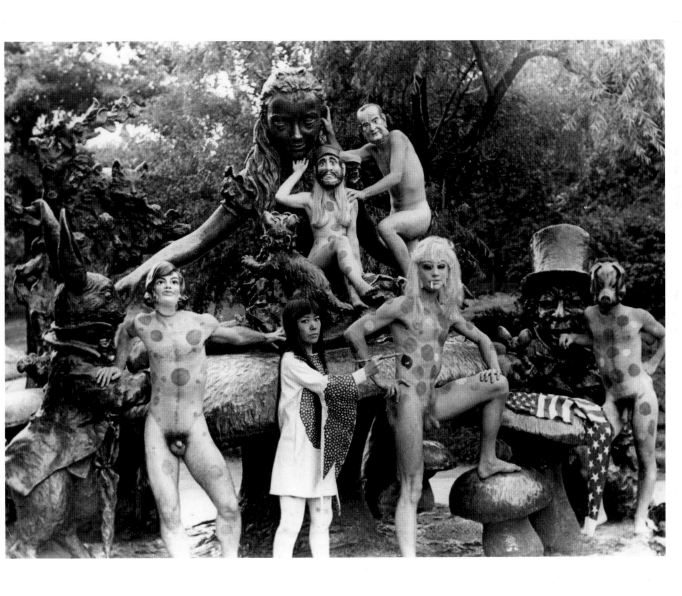

Yayoi Kusama, **The Anatomic Explosion Happening,**
at the Alice in Wonderland sculpture
(Naked Happening in Central Park), 1968, New York

ALLEN JONES
Women as Furniture series

1969

The exhibition of Allen Jones's *Women as Furniture* series in 1970 caused an uproar. His enslaved women in leather boots and bondage gear, constrained to make themselves useful as furniture, seemed to epitomize the exploitation of women. The Women's Liberation Movement protested. In 1973, Laura Mulvey would contribute a more subtle, Freudian critique of Pop Art, mass advertising, and Hollywood for fetishizing women to gratify the male gaze.

David Hockney had first suggested that Jones explore fetish magazines for inspiration. Jones says he is a feminist, and was responding to women signaling their liberation through increasingly revealing fashions. "I was living in Chelsea and I had an interest in the female figure and the sexual charge that comes from it. Every Saturday on the King's Road you went out and skirts were shorter, the body was being displayed in some new way.... I was reflecting on and commenting on exactly the same situation that was the source of the feminist movement. It was unfortunate for me that I produced the perfect image for them to show how women were being objectified."

Feminist critic Lisa Tickner retorted that Jones—and such Pop artists as Mel Ramos—reinforce negative stereotypes applied to women: "passivity, availability, narcissism, exhibitionism, physicality, mindlessness."

The bondage outfits on Jones' sculptures were made by the same company that created the costumes for Diana Riggs in her role as the powerful detective Emma Peel in the *Avengers* series, but Jones' sculptures represented disempowered women and were interpreted as disempowering them. Feminists vilified Jones: "Smoke bombs and stink bombs and God knows what were thrown at my ICA show in 1978. There was an incredible furor on the Mall. *The Guardian* suggested I should not be allowed to exhibit. It was tough stuff and I wasn't expecting it."

Stanley Kubrick invited Jones to create—without charge—similar figures for the set of the Korova Milkbar in his 1971 film *A Clockwork Orange*. Jones declined, affronted, but was commissioned to style Barbet Schroeder's 1976 film *Maîtresse*, which included graphic sadomasochism and was restricted in the UK and US. Forniphiliacs—who fetishize the body used as furniture—celebrate the sculptures of Jones and François-Rupert Carabin.

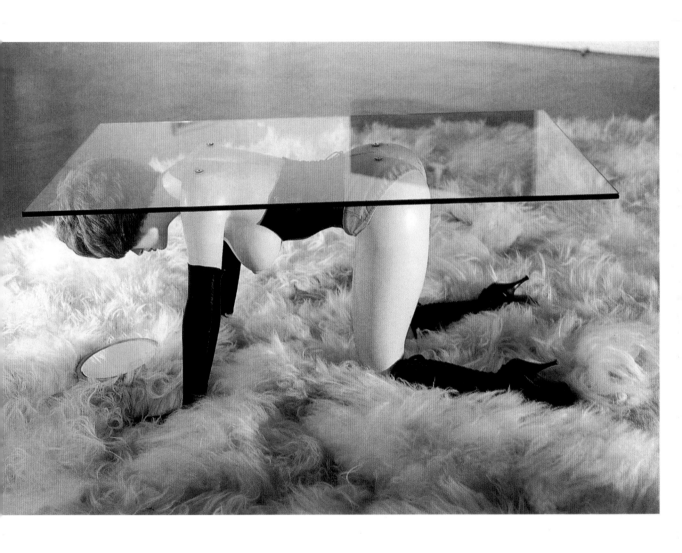

Allen Jones, **Women as Furniture series**, 1969,
fiberglass, leather, hair, glass, 24 x 57 x 33 in. (61 x 144.8 x 83.8 cm),
Ludwig-Forum, Aachen

CORITA KENT
american sampler

Corita Kent, also known as Sister Corita, became famous for her prints. Her influential style of combining words, bright colors, and bold graphics helped popularize the medium. She embraced silkscreen printing because she could produce numerous images—and multiple copies—inexpensively, and price them cheaply. Corita Kent's prints drew on spiritual, philosophical, and poetic writings, as well as messages drawn from advertising, popular culture, and pop music, to convey her moral and spiritual outlook, which included promoting social justice, peace, and love. But because of protests against the Vietnam War, peace in the sixties was politicized. Sister Corita's 1965 *Peace on Earth* Christmas exhibit in IBM's showroom in New York was seen as too subversive and Corita was forced to amend it.

american sampler employs the nation's colors—and a typeface reminiscent of fifties westerns—to set in motion wordplays and associations that pose the question of "SIN" and "American" "Violence" in relation to "Vietnam" and "Assassination." America had been rocked by the assassinations of Civil Rights activist Medgar Evers and President John F. Kennedy in 1963, and of Malcolm X in 1965, but the assassinations in 1968 of Martin Luther King Jr. and Bobby Kennedy, who promised an end to the carnage in Vietnam, caused Americans to feel that their country was in crisis and to question its values. In this work, Sister Corita links two brands of American violence—wars of dubious ethical legitimacy and handgun slayings—that continue to haunt the US.

Her 1985 "Love" postage stamp design with a swash of rainbow colors was the most popular of all time. Her local bishop tried to censor her, however, and she was told to cease making "weird and sinister" art. Cardinal John McIntyre called her a "guerilla with a paint brush." After the Second Vatican Council gave nuns more leeway to live in the modern world, Sister Corita was part of an effort to revise her order's charter; for starters, abandoning the old-fashioned habit. The bishop responded by firing the nuns from Catholic schools in the archdiocese. The feud went all the way to the Vatican, which sided with the bishop. In 1968, Corita "left the order," and moved to Boston, where her 150-foot (46-meter) mural still brightens the flanks of a gas-storage tank near the Southeast Expressway.

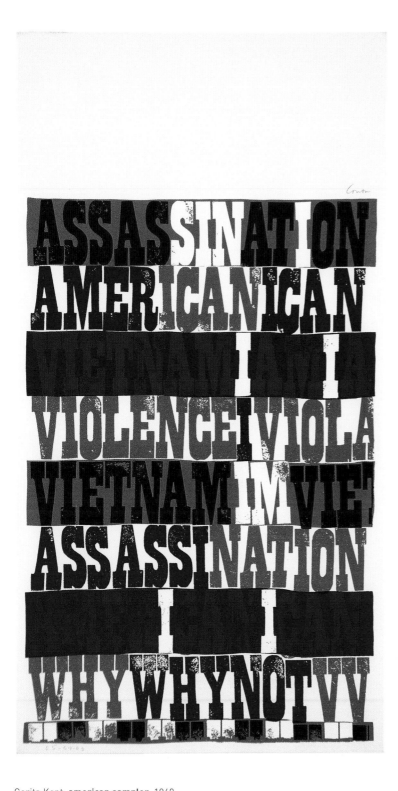

Corita Kent, **american sampler**, 1969,
serigraph, 23 x 12 in. (58.5 x 30.6 cm),
Collection Martin Beck

JIM DINE
Four Hearts

Jim Dine mixed with and showed with the early Pop artists in New York, and was an early participant in and originator of happenings. Dine's *The House*, shown alongside Oldenburg's *The Street* at the Judson Gallery (1960) signaled their shared interest in everyday objects, subjects, and materials drawn from the street and its detritus, and in comics, which they designed for the show.

Dine's assemblages, shown alongside Kurt Schwitters, Hans Arp, Jasper Johns, Robert Rauschenberg, and Claes Oldenburg in *New Media—New Forms: In Painting and Sculpture* (1960) placed Dine among the "Neo-Dadaists." In September 1962, he was included, along with Roy Lichtenstein, Edward Ruscha, Wayne Thiebaud, Andy Warhol, and others in Walter Hopps's *New Painting of Common Objects*, often called the first Pop Art museum exhibition in America. In November 1962 he showed in the *International Exhibition of the New Realists* at Sidney Janis Gallery, along with Oldenburg, George Segal, and Tom Wesselmann, followed by Lawrence Alloway's *Six Painters and the Object* at the Guggenheim in 1963, along with Johns, Rauschenberg, Lichtenstein, Rosenquist, and Warhol. These shows

primed the participants' recognition as Pop artists.

Jim Dine's works featured popular, everyday, and personal objects, such as hearts, tools, and his bathrobe. Asked about his fascination with hearts, Jim Dine said: "It's mine and I use it as a template for all my emotions. It's a landscape for everything." A dyslexic, poetry kept him "in the world of language," and he also wrote words into his works. His subjects held autobiographic and symbolic value to him, and his handmade, painterly style did not share the flat, mechanical surfaces that came to typify Pop. Though hailed as a Pop pioneer, like the multitalented Larry Rivers, he saw Pop as but one facet of his personal and subjective approach to painting.

Dine and Rivers also shared an interest in eroticism. They showed with Allen Jones, Richard Lindner, Marisol, Warhol, and Wesselmann in *Erotic Art '66* at Sidney Janis. Dine's show at Robert Fraser Gallery in London in 1966 was raided by the police and shut on the grounds of "obscenity" because images of genitalia were visible from the street. Later ruled "indecent," the incident highlights the clash caused by sexual liberation in Swinging Sixties London.

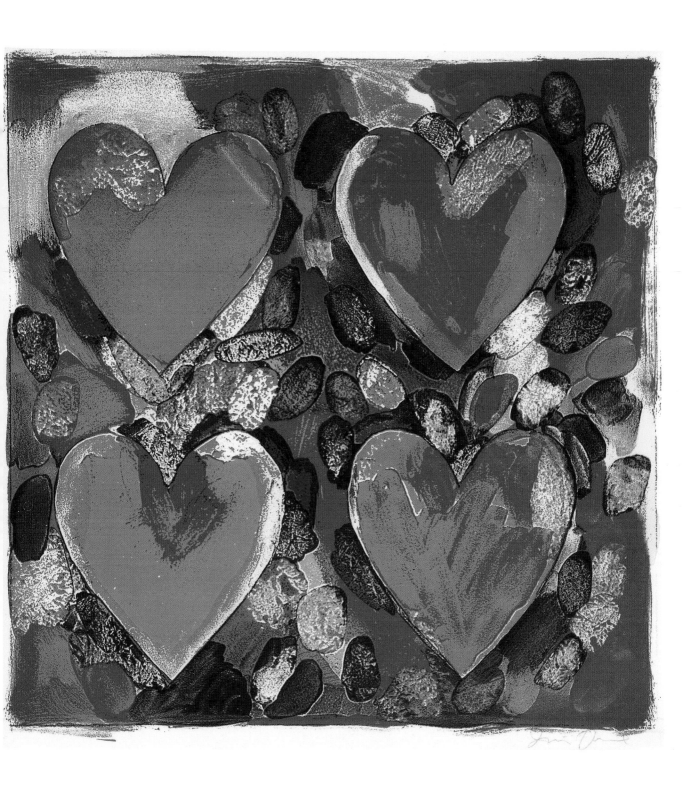

Jim Dine, **Four Hearts**, 1969,
screenprint on paper, 12.8 x 12.5 in. (32.4 x 31.8 cm), Tate, London

ROBERT INDIANA
LOVE

The many iterations of Robert Indiana's *LOVE* sculpture around the world and in different languages are among the most loved and photographed of all Pop Art icons.

LOVE has often been read in light of the hippie and peace movements' advocacy of love over war during the turbulent 1960s. Robert Indiana's inspiration was, however, religious, he says: "God is Love" was inscribed on the pulpit of the Christian Science church his family attended. It was religious feeling, too, that caused him to drop his surname, Clark, and adopt "Indiana," after the state where his family had lived, moving twenty-one times before Robert turned nineteen. He had felt reborn after completing his mural *Stavrosis*—Greek for "crucifixion"—and renamed himself.

"Love," even in the Christian context, is not straightforward. Theologians distinguish three types of love in Greek: *eros* (sexual), *philia* (friendship), and *agapé*—the selfless love of sharing and of sacrifice in which the individual is subsumed in the collective. Robert Indiana's poems, sculptures, and rubbings from the early sixties reference love in different guises, and he first stacked the letters in a 1958 poem.

Indiana drew *LOVE* cards for friends, and painted a Christmas-card design of stacked red and green letters on blue for MoMA in 1965. He repeated that design as a silkscreened exhibition poster for his "LOVE show" at Stable Gallery in 1966, where he exhibited a small aluminum *LOVE* sculpture, drawings, and hard-edge paintings. He told an interviewer that his poster colors were inspired by giant red-and-green signs for Phillips 66 gas stations, which he saw against the cerulean Hoosier sky when his mother drove his father to Phillips 66, where he worked for so long that he got a loyalty lapel pin. "Therefore," Indiana said, "*LOVE* is a homage to my father"—an expression of filial love.

Evidently, like the public that never tires of posing on, in, or with *LOVE*, Indiana's stance toward his work varies. He has, for example, explained the slanting "*O*" in many ways—as a cat's eye, even as an erect phallus. The storied *O* inserts dynamism into the composition.

The US Postal Service's 1973 *LOVE* stamp for Valentine's Day was a best seller, and Indiana's *HOPE* (2008) raised more than a million dollars for the Obama presidential campaign.

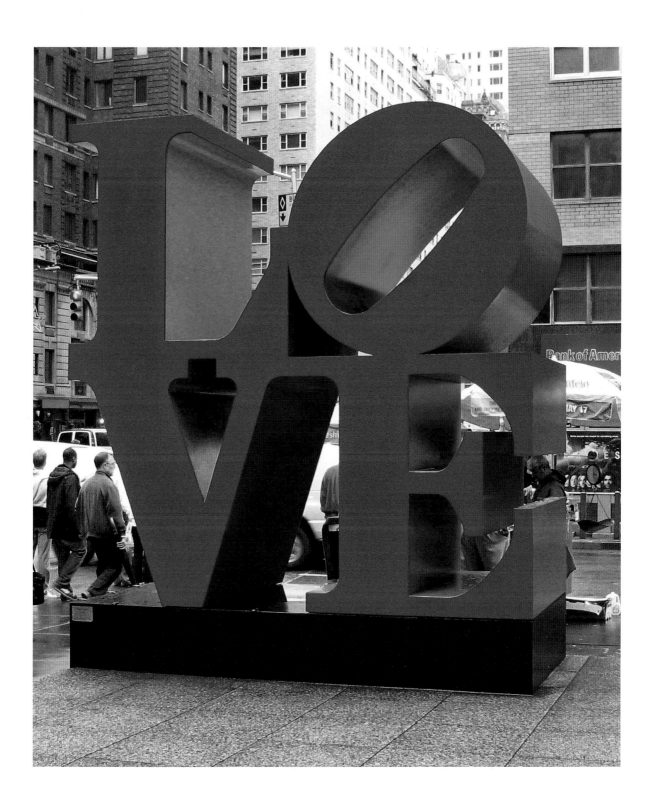

Robert Indiana, **LOVE**, 1970,
cor-ten steel, 144 x 144 x 72 in. (370 x 370 x 180 cm), New York

47

MEL RAMOS
Coca Cola #2

1971

Like some other Pop artists in this book, it is not so much a single work of Ramos's that the Pop Art aficionado should know, but his role and output within Pop Art. Ramos juxtaposes commodities and sex-symbol women, shrunken so that the products dominate them. At first sight, this wittily reverses the scale of advertisements that try to sell big things, like cars, by draping buxom "babes" on them. Though the point wears thin—fast—Ramos repeated this formula for decades from 1965. While it had some currency in the era of *Playboy* magazine, pinups pandering to male fantasy suited the garage better than the living room or museum, and many women reviled such work as sexist.

Discussing a 2009 Ramos career survey in New York in 2009, critic Ken Johnson raised issues surrounding bad-taste sexuality in the work of Ramos and others. While artists like Roy Lichtenstein and "Tom Wesselmann could get away with repeatedly using the female nude by flattening, fragmenting and otherwise abstracting the figure and thereby making it a conceptually loaded sign rather than a pornographic image, Mr. Ramos kept the figure intact and sexually desirable, and as such his work was too close to a kind of soft-core illustration for the serious art world's taste."

In the 1990s, however, much brasher sexual work entered the art world, echoing the ready availability of pornography in the Internet age: Jeff Koon's works of him having sex with the porn star he was then married to, and the distorted women in the paintings of Lisa Yuskavage and John Currin. Pornography, marketed to the masses, is today part of "popular culture," and perhaps that qualifies porn as the subject of some type of Neo-Pop. As Johnson points out, "the modern art worlds of Europe and America have never fully accepted art made for arousal as high art, but why should arousal be any less worthy an aim than, say, trying to inspire religious feelings." Eroticism was acceptable in earlier Western art and in Indian and Japanese art, and it is accepted in such writers (often after a fight) as the Marquis de Sade, D. H. Lawrence, Henry Miller, and André Gide. However, today Mel Ramos's "sexy dames" look tame, even retro, evoking nostalgia for a less sexually inured era when such images held suggestive frisson.

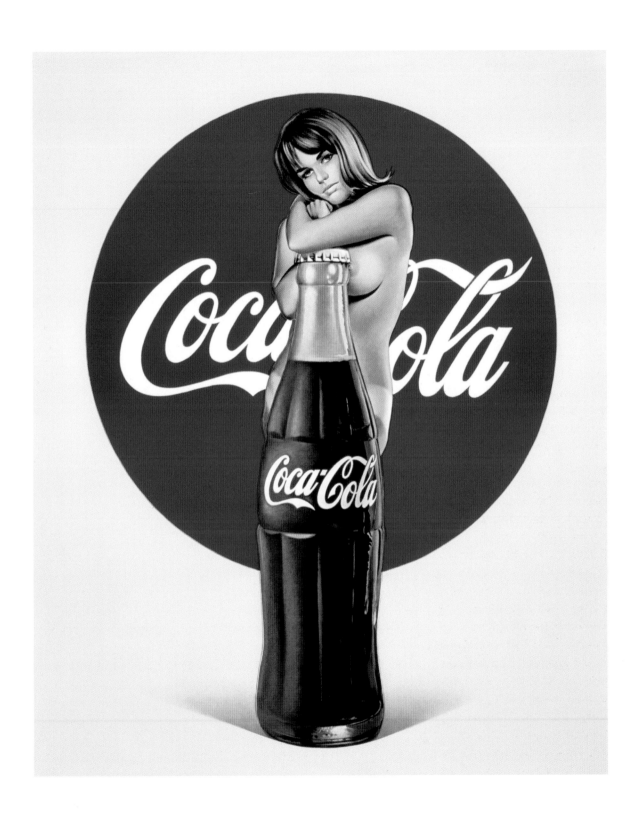

Mel Ramos, **Coca Cola #2**, 1971,
oil on canvas, 60 x 50 in. (152.4 x 127 cm)

LUCAS SAMARAS
Photo-Transformation: September 9, 1976

The Getty Museum, which owns this work, notes of it: "As if engaging in a tug-of-war with himself, Lucas Samaras confronts and struggles with his own reflection in this self-portrait." Samaras's set is his apartment, often the kitchen, and his staging of the scene depends not only on mirrors but also on dramatic shadows and lighting that have much in common with low-budget film and film noir.

Samaras's series of self-portrait *Autoportraits* (begun in 1969) and *Photo-Transformations* (1973–76) constitute a multifaceted self-portrait. Pop Art elements in Samaras's work include the repetition of the photographed subject and the narcissistic focus on the self, via mirroring. Samaras embraced a new popular medium—Polaroid photography—and transformed it—by manipulating the emulsion dyes in the sandwiched format before they set—not unlike how Warhol appropriated silkscreen, the Photomat, or home-movie films, or Chryssa neon light. Like them, Samaras bent the medium to his own aesthetic concerns. The effect is strangely beautiful, surreal, even hallucinogenic.

However, Samaras's output—he was an established sculptor, installation artist (*Room*, 1964), painter, and participant in the first happenings (1959) before turning to photography—is rarely considered in the context of Pop Art. Exceptions include the exhibitions *Sinister Pop*, at the Whitney Museum of American Art (2013); *Mixed Media and Pop Art*, at Albright-Knox Art Gallery (1963); and *The Great American Pop Art Store*, which traveled to several venues. In part, this is because he prefers hermit-like isolation, and his work has affinities with Surrealist anxieties. His mirror installations, like those of Yayoi Kusama and Dan Graham, have an antecedent in Kurt Schwitters's *Merzbau*, which Schwitters had first called "Cathedral of Erotic Misery." Psychosexual torment and the radical disorientation of mirror installations carry over into the split "selves" in Samaras's Polaroid portraits. While the mythic Narcissus was frozen because of his vanity, Samaras's narcissism proclaims the staging of the mirror and simultaneously disorients, fragments, and/or proliferates the human subject.

Samaras's performance-based self-portraits paralleled contemporary video works, and later influenced artists such as Cindy Sherman.

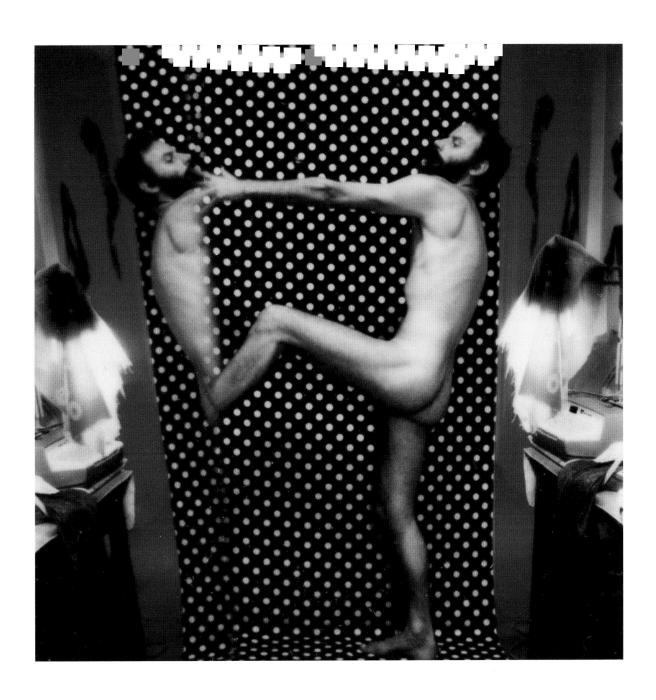

Lucas Samaras, **Photo-Transformation: September 9, 1976**, 1976,
polaroid SX-70 print, 3 x 3 in. (7.6 x 7.6 cm),
The J. Paul Getty Museum, Los Angeles

GEORGE SEGAL
Gay Liberation

George Segal is famous for his life-size figures derived from plaster bandages applied onto live models. Sometimes, Segal cast bronze versions, which he often then patinated white to look like plaster—as in *Gay Liberation*. Segal's sculptures are usually set up in public places where they become part of the scene. His sometimes realistically colored sculptures are easily mistaken for real people going about everyday life.

Gay Liberation consists of two benches and a male couple and a female couple that touch with affectionate intimacy. Today, after long policy battles, they are installed in Christopher Park opposite Greenwich Village's Stonewall Inn, where the Gay Liberation movement began before dawn on June 28, 1969. A police raid on the gay bar resulted in thirteen arrests and provoked the Stonewall Riots as clients and observers fought back. Hundreds protested the next day, demanding the legalization of gay bars. Continuing protests in July included the first gay and lesbian march, from Washington Square to Stonewall Inn, on July 27, 1969—the precursor of Gay Pride marches worldwide.

Dr. Bruce Voeller, co-founder of the National Gay and Lesbian Task Force and the Mariposa Foundation, conceived the idea for a sculpture to honor gay rights for the tenth anniversary of Stonewall, supported by the Mildred Andrews Fund for public art endowed by Peter Putnam. Bruce Voeller could not persuade a gay or lesbian artist to take the commission. Segal had completed a memorial Putnam commissioned for the student protestors killed by the Ohio State Guard in 1970 at Kent State University, and had already depicted gay couples in other works; he was unafraid of controversy, and he took the job.

Plans to erect one edition in Greenwich Village and a second in Los Angeles were stalled by residents' objections, particularly Catholics. The second cast, erected on loan at Stanford University, was soon vandalized (1984). Reinstalled, it was then spray-painted with the word AIDS (1986) and splattered with black in 1994. The New York casting was erected only in 1992. Despite criticisms that the figures were too white and the artist was not gay, the group is now a beloved fixture. On June 24, 2012, when the New York legislature legalized gay marriage, thousands of celebrants surrounded Segal's figures in Christopher Park.

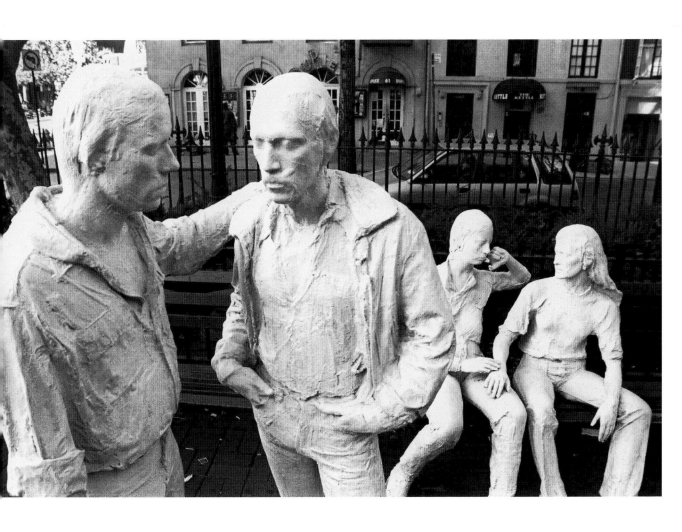

George Segal, **Gay Liberation**, 1979–80,
bronze, whitewashed,
Christopher Park, New York

ALLAN D'ARCANGELO
Smoke Dream

Allan D'Arcangelo's most well-known images—such as *US Highway 1* (1962)—are flat, two-dimensional American landscapes, framed through a car windscreen, the headlights illuminating the road signs and the highway unraveling like a black ribbon into infinity. The sharp, geometric shapes and exaggerated perspective are like those in cartoons and movies. In these respects, his work had much in common with the features of Pop Art, and particularly with the work of Ed Ruscha.

In 1960, American was a little more than half as populous (179 million) as it is now (over 315 million). Then, even more than today, commercial signs, erected on rented footprints in America's wide-open spaces, floated in the darkness like alien presences. They signify the omnipresence of corporate capital, marketing to the driver's needs or desires—even in the middle of nowhere—alongside common indications about speed limits and lanes. D'Arcangelo's visions show that "nowhere" is owned and regulated; in other words, there is no "nowhere," and Big Brother is everywhere, too. Yet, the open road at night suggests freedom. One can speed down the tunnel cast by the headlight beams without much thought or distraction. The landscape is simultaneously a vast terra incognita and yet tamed, neatly paved, and signposted. You are unlikely to get lost.

After World War II, the power lines running parallel to the road wired even the farthest-flung frontiers of America into the networks of mass marketing. In *Smoke Dream*, D'Arcangelo's roadway is more confusing than in his earlier works, viewed triple, as if by a drunken driver. The landscape's association with women is much more explicit, though. The dark hills are furry mounds; a blond Venus reclines, smoking as if sexually satiated, smiling in a familiar way. A butterfly, symbol of virginity, flies off into the night. This recent work is much less innocent than D'Arcangelo's earlier work. It seems to imply that the promise of the open road, which one could still relish in the 1960s, has evaporated. There is virtually no perspectival narrowing of the road to imply progression; instead, multiple roads shoot up into the sky, or, more accurately, into the body of the woman. The sense of promise has literally gone up in smoke; the reverie of the open road has become territorialized by the looming body of this female stereotype. She is the ad that ate the sky.

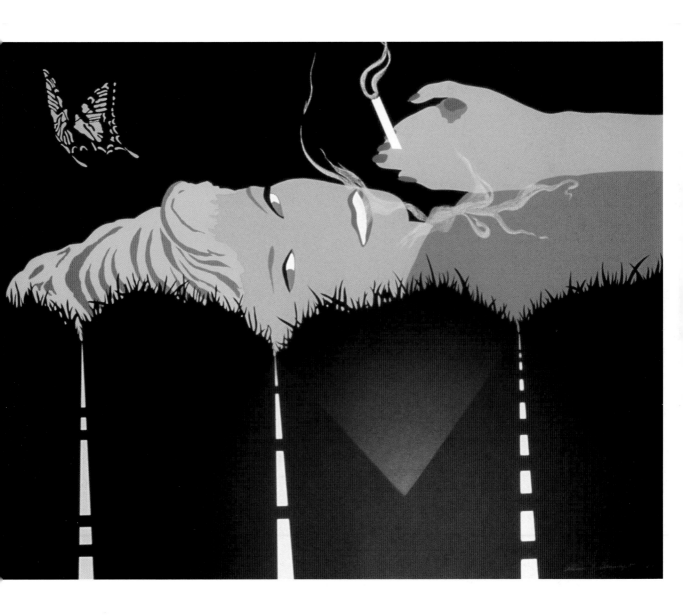

Allan D'Arcangelo, **Smoke Dream**, 1990,
screenprint on paper, 37.6 x 47 in. (95.5 x 119.4 cm)

BIOGRAPHIES

EVELYNE AXELL
(1935–1972)

Born Evelyn Devaux in Namur, Belgium, she studied pottery and drama and worked as an actress from 1955 to 1962. Axell took private art lessons with René Magritte, and began her work as an artist in 1962. In 1956, she married documentary filmmaker Jean Antoine. Axell accompanied him in 1964 while he made a film on Pop Art in Britain, and met Peter Blake, Pauline Boty, Allen Jones, and other British Pop artists. Her *Erotomobiles* paintings won an honorable mention in the Young Belgian Painters Prize in 1966, which she won in 1969. She had her solo debut and a second solo show at Palais des Beaux-Arts, Brussels in 1967 and 1971. Her 1970 *Le Peintre (Auto-portrait)* is said to be the first nude self-portrait by a woman artist. She died following a car accident.

Liesbeth Decan, "Evelyne Axell (1935–1972): A Belgian Surrealist Pop Artist?," in *Collective Inventions: Surrealism in Belgium*, ed. Patricia Allmer and Hilde Van Gelder (Leuven, 2007), p. 154.

www.evelyne-axell.com

PETER BLAKE
(b. 1932)

Born in Dartford, Kent, England, Blake studied first at the Royal College of Art and then explored popular art in Europe on a Leverhulme Research Award (1956–57). He featured in Ken Russell's 1961 documentary on British Pop Art, *Pop Goes the Easel*, with Derek Boshier, Pauline Boty, and Peter Phillips. He married Jann Haworth in 1962; they separated in 1979. Through gallerist Robert Fraser, Blake met such music stars as the Beatles (1963). The Stedelijk Museum in Amsterdam organized his first traveling retrospective (1973–74). A founder of the "Brotherhood of Ruralists," isolation in the countryside dampened his career. He avoided bankruptcy by producing prints, which he once disdained as commercialism. Honored with a CBE in 1983, he was knighted in 2002. He designed record covers for the Who, Eric Clapton, and his former student Ian Drury.

"Beatles Artist Peter Blake Reveals Queen Portrait And Discusses Financial Troubles," *Huffington Post*, May 29, 2012, http://www. huffingtonpost.co.uk/2012/05/29/peter-blake-beatles-queen-portrait_n_1551717.html. Interview with Jann Haworth, "Still Swinging After All These Years?," *TATE, ETC.*, no. 1 (Summer 2004).

DEREK BOSHIER
(b. 1937)

Born in Portsmouth, England, after art school Boshier attended the Royal College of Art in London (1959–62); he spent a year in India on a travel scholarship, and visited the United States in 1964. He has taught art at the Royal College of Art; in Vancouver Island, Canada; Houston, Texas (1980–92, 1995), and has taught drawing at UCLA since 1997. Boshier works in several media, including sculpture and installation, and exhibits regularly. He is stylistically eclectic. He featured in Ken Russell's 1962 documentary *Pop Goes the Easel* with Peter Blake, Pauline Boty, and Peter Phillips, and acted as the artist Millais in Russell's 1967 feature *Dante's Inferno.* He made four experimental films in the 1970s. His graphic designs of a fallen Everyman for David Bowie's record *Lodger* and for the Clash's songbook reached millions of viewers.

Thomas Crow, "London Calling," *Artforum International* (Summer 1993).

Pop Art Redefined, ed. John Russell and Suzi Gablik, exh. cat. Haywood Gallery (London, 1969).

John A. Walker. "Derek Boshier's Drawings from America." *Jamini: An International Arts Quarterly* 2, no. 4 (2005), pp. 80–85.

www.derekboshier.com

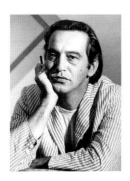

CHRYSSA
(b. 1933)

Born Chryssa Mavromichali (later Vardea) and raised in Athens, Greece, after a disillusioning stint as a social worker she went to study art in Paris, then at the California School of Fine Arts (1954). She settled in New York and became an American citizen in 1955. Following her 1961 solo debut at the Guggenheim, she featured in *Americans 1963* at MoMA, and had important solo shows at the Whitney in 1972, the Institute of Contemporary Art, Philadelphia (1965), and the Musée de l'Art Moderne de la Ville de Paris (1979), among others. A major retrospective was staged at the Mihalariars Art Center, Athens, in 1990. Her *Mott Street* is a major work installed in Athens' Evangelismos subway station. Several monographs on Chryssa's work have been published.

Douglas Schultz, *Chryssa: Cityscapes*. London: Thames & Hudson, 1990.
Sam Hunter, Chryssa. New York: Thames & Hudson, 1974.

ALLAN D'ARCANGELO
(1930–1998)

Born in Buffalo, New York, D'Arcangelo studied at the University of Buffalo (1948–53) and the New School (1953) and City College in New York. He began his long teaching career at the School of Visual Arts in New York in 1957, and became professor emeritus at Brooklyn College. On the G. I. Bill he studied painting and exhibited in Mexico City (1957–59). Friends with Boris Lurie and Sam Goodman of March Gallery, he shared their social concerns. He collaborated with Goodman on theater pieces used during "Ban the Bomb" demonstrations in 1961–62. His New York solo debut at Fischbach Gallery (1963) gained him lasting recognition as a Pop artist, and ensured his inclusion in many key surveys of Pop Art. He was an invited muralist for the 1964 New York World's Fair, and was included in the influential *American Landscape Painting* exhibition at MoMA in 1964. He exhibited regularly in Europe and New York throughout the 1960s, and in the 1970s was included in MoMA's *American Art Since 1945* (1976) and had a solo museum show at the Virginia Museum of Fine Arts (1979). In 1987–88 he received a Guggenheim Fellowship.

Dan Cameron, *Allan D'Arcangelo: Paintings, 1962–1982*, exh. cat. Mitchell-Innes & Nash (New York, 2009).
Allan D'Arcangelo, "Paintings of the Early Sixties" (1978), in *NO!art Anthology: Pin-Ups, Excrement, Protest, Jew-Art*, ed. Boris Lurie and Seymour Krim (Cologne, 1988).

www.allandarcangelo.com/

CHRISTA DICHGANS
(b. 1940)

Born in Berlin, Germany, Dichgans moved to New York on a German National Academic Foundation scholarship (1966–67) and then lived in Rome (1967–68). She has shown frequently throughout her career, with her solo debut at Lempertz Contempora in Cologne in 1967, followed by solo exhibitions at Berlin's Galerie Springer (1971–72). Mr. Springer became her second husband. During 1971 she had a residency at the Villa Romana, Florence. Her 1985 retrospective was shown at Städtische Galerie im Park Viersen and at Mannheimer Kunstverein. Another retrospective of her pictures was organized by Haus am Waldsee, Berlin (1992). Her toy paintings of 1967–77 were shown at Galerie Daniel Blau, Munich (2010). She was an assistant to Georg Baselitz at the Hochschule der Künste in Berlin from 1984 to 1988.

Belinda Grace Gardner, "Christa Dichgans", in *Power Up: Female Pop Art*, exh. cat. Kunsthalle Wien, Vienna, 2010.

JIM DINE
(b.1935)

Born in Cincinnati, Ohio, he was educated at Ohio University (MFA, 1957). Dine worked in his grandparents' hardware store. He describes his father as "a bum"; his mother died when he was twelve, so he "took care of himself." His work is self-analytical, and Dine spent decades in therapy. He moved to New York in 1958 and first gained recognition for happenings. Several notable exhibition appearances followed, and he showed in the 1964 Venice Biennale. He relocated his family to England (1967–71), where he focused on drawing—which he sees as the basis for all his work—and printmaking. Museum retrospectives of his work were held at the Whitney Museum of American Art (1970), the Walker Art Center in Minneapolis (1984–85), the Guggenheim, New York (1999), and the National Gallery of Art in Washington, D.C. (2004).

Ilka Skobie. "Lone Wolf: An Interview with Jim Dine." *Artnet*, http://www.artnet.com/magazineus/features/scobie/jim-dine6-28-10.asp.

ROSALYN DREXLER
(b.1926)

Born Rosalyn Bronznick in the Bronx, Drexler attended New York's High School of Music and Art, where she majored in voice, and attended one semester at Hunter College before leaving to marry the painter Sherman Drexler in 1946. During 1951, she wrestled professionally as Rosa Carlo, the "Mexican Spitfire," inspiring a series of Andy Warhol works. She participated in the first happenings at the Reuben Gallery in New York, showed sculptures of found objects at her solo debut there, and featured in the 1960 exhibition *New Forms—New Media II* at the Martha Jackson Gallery, a show which played a critical role in launching Pop Art. She turned to painting during the sixties. She arranged enlarged topical photographic images on flat, sometimes brightly colored backgrounds, with incisive commentary and unsettling content. Fresh research on neglected women Pop artists has brought her overdue recognition. She is also an accomplished writer, with numerous novels, plays, screenplays, and prestigious awards to her name.

Bradford R. Collins, "Reclamations: Rosalyn Drexler's Early Pop Paintings, 1961–1967," in *Seductive Subversion: Women Pop Artists, 1958–1968*, ed. Sid Sachs and Kalliopi Minioudaki, exh. cat. Rosenwald-Wolf Gallery, Philadelphia (New York and London, 2010). Dana Heller, "Shooting Solanas: Radical Feminist History and the Technology of Failure," in *Feminist Time against Nation Time: Gender, Politics, and the Nation-State in an Age of Permanent War*, ed. Victoria Hesford and Lisa Diedrich (Lanham, MD, 2008).

MARCEL DUCHAMP
(1887–1968)

Born near Blainville, France, Duchamp's conceptual strategies fundamentally altered the course of modern art. His *Nude Descending a Staircase No. 2* (1912) introduced time and movement into painting, expressing modernity. After settling in New York in 1915, he became the center of the New York Dada circle. Duchamp's addition of the letters LHOOQ to a reproduction of the Mona Lisa created a typical Dada pun—a crude sexual one. Like his Readymades, it showed how a conceptual gesture could transform the identity of an artwork, just as a found object could become art. Duchamp opposed the Abstract Expressionists, and many of the Pop artists in this book looked to Duchamp as they forged their own paths far from Abstract Expressionist heroics.

Francis M. Naumann, *Marcel Duchamp: the art of making art in the age of mechanical reproduction*. New York: Harry N. Abrams, 1999.

RICHARD HAMILTON
(1922–2011)

Born in Pimlico, London, Hamilton taught at London's Central School of Arts and Crafts with Eduardo Paolozzi, and the two founded the Independent Group. Hamilton designed the ICA exhibitions *Growth and Form* (1951), opened by Le Corbusier, and *Man, Machine and Motion* (1955). He participated in the 1956 *This is Tomorrow* exhibition. Hamilton's print series *Swingeing London 67* was based on press images of his gallerist Robert Fraser and Mick Jagger in a police vehicle, arrested for smoking pot. After befriending Paul McCartney, Hamilton designed the Beatles' *White Album* cover and poster. His lifelong interest in Duchamp led to a friendship, Hamilton's authorized reproduction of Duchamp's *The Large Glass*, and his organization of the Tate's Duchamp retrospective in 1966. Retrospectives of Hamilton's work have been held at the Guggenheim (1974) and the Tate (1979, 1992, 2013–14). His *Collected Words, 1953–1982* was published in 1985.

John-Paul Stonard, "Pop in the Age of Boom: Richard Hamilton's *Just what is it that makes today's homes so different, so appealing?*," *The Burlington Magazine* 149, no.1254 (September 2007).

JANN HAWORTH
(b.1942)

Born in Hollywood, California, Haworth studied art at UCLA (1960); the Courtauld Institute, London (1961); and the Slade School of Fine Art (1962–63). She was a pioneer of soft sculpture and received a Grammy Award for designing the cover of the Beatles' *Sgt. Pepper's*. In 2004–05, she embarked on a collaborative community project to paint a thirty-eight-by-forty-eight-foot mural, entitled *SLCPepper*, that updates the *Sgt. Pepper's* image with characters nominated by Salt Lake City residents. "To make such a big picture and actually review history, to say we have come so far since 1967; we talk a different language, we appreciate different things and the cultural diversity is in such a better state. We've traveled in that time and that was thrilling. To correct 'Sgt. Pepper' was very important to me." Jann Haworth has produced three children's books on art techniques, and illustrated several publications.

Dave Gagon, "It was 40 years ago today …: Local Artist Jann Haworth Helped Shape the Beatles' Iconic 'Sgt. Pepper' Cover," *Deseret News*, July 22, 2007, http://www.deseretnews.com/article/695193700/It-was-40-years-ago-today-.html?pg=all.

DAVID HOCKNEY
(b.1937)

Born in Bradford, England, Hockney was a conscientious objector who worked in hospitals for the national health service. He graduated from the Royal College of Art in 1959 wearing a gold lamé jacket. He gained early recognition as a Pop artist through the British *Young Contemporaries* exhibitions. His work has been well received ever since, with numerous popular exhibitions, including the 2012 exhibition *A Bigger Picture* that welcomed more than 600,000 visitors. In 2011, his British peers voted him the most influential British artist ever, recognizing the depth and breadth of his works, which includes drawings, prints, paintings, photography, and also his set and costume designs for the ballet, opera, and theater, which are inspired by his synesthesia. He has enthusiastically embraced new materials and technologies throughout his career.

Dalya Alberge, "Hockney Named Britain's Most Influential Artist," *The Independent*, November 23, 2011.
"David Hockney: A Bigger Splash, 1967," Tate website, http://www.tate.org.uk/art/artworks/hockney-a-bigger-splash-t03254/text-summary.
Alastair Sooke, "David Hockney: A Bigger Picture, Royal Academy of Arts, Review," *The Telegraph*, January 16, 2012.
Edmund White. "Sunlight, Beaches and Boys." *The Guardian*, September 7, 2006.

ROBERT INDIANA
(b. 1928)

Born Robert Clark in New Castle, Indiana,
he trained at the School of the Art Institute
of Chicago and at the University of Edinburgh
in Scotland. His New York solo debut was at
Stable Gallery (1962) and has since had more
than thirty solo exhibitions. He was the star of
Andy Warhol's film *Eat* (1964). Indiana created
several works entitled *Eat*, recalling the sign
at the diner where his mother worked. His
enormous "EAT" sign at the New York World's
Fair (1964) confused visitors into expecting
food. Warhol and Indiana posed together,
holding cats, for *Vogue* (March 1965). The
Smithsonian National Museum of Art held
a retrospective of works from Indiana's per-
sonal collection in 1982, and the Portland
Museum of Art, in Maine, where he lives,
staged a major retrospective in 1999.

Wikipedia contributors, "List_of_Love_
scultpures," *Wikipedia, The Free Encyclope-
dia,* http://en.wikipedia.org/wiki/List_of_
Love_sculptures.
Susan Elizabeth Ryan, *Robert Indiana:
Figures of Speech.* (New Haven and London,
2000).

www.robertindiana.com

JASPER JOHNS
(b. 1930)

Born in Augusta, Georgia, Johns studied art
at the University of South Carolina (1947–48)
before moving to New York in 1948 and study-
ing at Parsons. After completing military
service he returned to New York in 1953. His
mutually inspiring relationship with Robert
Rauschenberg propelled their careers as pro-
genitors of Pop Art. Johns's New York solo
debut in January 1958 at the Leo Castelli Gal-
lery, featured on the cover of *Art in America*,
propelled him to fame; MoMA purchased
three works from the show, and he was
included in the Venice Biennale that year. He
would receive the Grand Prize for Painting at
the 1988 edition of the event. Johns and
Rauschenberg took part in Allan Kaprow's
Eighteen Happenings in Six Parts (1959), and
Johns was included in the *Sixteen Americans*
exhibition at MoMA (1960). The Jewish
Museum, New York, held his first retrospec-
tive exhibition (1964), followed by an interna-
tional traveling retrospective organized by the
Whitney Museum of American Art (1977), and
another at MoMA (1996).

Bilge Aydoğan, "Jasper Johns and His Ordi-
nary Things," *İzinsiz Gösteri,* no. 177 (October
15, 2005).
Richard Francis, *Jasper Johns* (New York,
1984).

ALLEN JONES
(b. 1937)

Born in Southampton, England, Jones trained
at Hornsey College of Art in London (1955–
61), and was expelled from the Royal College
of Art (where his peers included David Hock-
ney and Derek Boshier) in 1960. In 1963, he
was awarded the Prix des Jeunes Artistes at
the Paris Biennale, and in 1964 he lived in
New York. He has taught at the Hochschule
für Bildende Künste, Hamburg (1968–70), the
University of Los Angeles, Irvine (1973), UCLA
(1977), the University of South Florida, Tampa
(1969), the Banff Center School of Fine Arts
in Alberta, Canada (Summer 1977), and the
Hochschule der Künste, Berlin (1982–83). He
visited Japan in 1974, and toured Canada in
1975. His 1979 retrospective showed at the
Walker Art Gallery, Liverpool (1979), the Ser-
pentine Gallery, London, and other venues. In
1986 Jones was made Royal Academician by
the UK Royal Academy of Arts. In 2007–08 his
paintings were featured at the Tate, in *Pop Art
Portraits* at the National Portrait Gallery, and
at the Royal Academy.

Martin Gayford, "Allen Jones: The Day I
Turned Down Stanley Kubrick, *The Telegraph,*
October 8, 2007.
Laura Mulvey, "You Don't Know What's
Happening, Do You Mr. Jones," *Spare Rib* 8
(February 1973).
Lisa Tickner, "Allen Jones in Retrospect:
A Serpentine Review," *Block* 1 (1979),
pp. 39–45.

ALLAN KAPROW
(1927–2006)

Kaprow was born in Atlantic City, New Jersey
and received his early education in Tucson,
Arizona (1933–42). He attended the High
School of Music and Art in New York and then
studied painting at Hans Hofmann's School of
Fine Arts (1947–48). He studied at New York
University (1945–50), Columbia University
(1950–52), and composition with John Cage
at the New School for Social Research (1957–
58). While teaching at Rutgers University in
New Jersey (1953–61), he helped found the
Fluxus group and staged the first happenings,
which initiated performance art, or new
media art. He also taught at the Pratt Institute
(1960–61), the State University of New York at
Stony Brook (1961–66), the California Institute
of the Arts (1966–74), and at the University of
California, San Diego (1974–93). His *Essays
on the Blurring of Art and Life* (1993), edited
by Jeff Kelley, contains much of Kaprow's
writings.

Kirstie Beaven, "Performance Art 101: The
Happening, Allan Kaprow," *Tate Blog*, May 30,
2012, http://www.tate.org.uk/context-com-
ment/blogs/performance-art-101-happen-
ing-allan-kaprow.
Donna Conwell, "Overflow: A Reinvention of
Allan Kaprow's *Fluids*, by the LA Art Girls."
Getty Research Journal, no.4 (2012), pp.201–
10.
Jori Finkel, "Happenings are Happening
Again," *New York Times*, April 13, 2008.
"Allan Kaprow. Art as Life," *AbsoluteArts.
com*, http://www.absolutearts.com/
artsnews/2006/10/19/34198.html.

CORITA KENT
(1918–1986)

Born Frances Elizabeth Kent in Fort Dodge,
Iowa, she became Sister Mary Corita when
she joined the Order of the Immaculate Heart
of Mary in Los Angeles in 1936, graduating
from their college in 1941 and later the head
of the art department. She received her MA
from the University of Southern California
(1951). Her progressive approach upset con-
servative Catholics. In 1967, *Newsweek* mag-
azine featured her on the cover. She invited
such creators as Alfred Hitchcock, John Cage,
and the designers Charles and Ray Eames to
lecture her classes, which became like hap-
penings. Buckminster Fuller called his visit
"one of the most fundamentally inspiring
experiences of my life." Sister Corita's "ten
rules of teaching" were enshrined in the
Essential Whole Earth Catalog. John Cage
popularized them. In 1968, she left the Order
and moved to Boston.

Lauren Feeny, "Sister Corita Kent's 'Radical'
Art," Moyers & Company website, June 22,
2012, http://billmoyers.com/2012/06/22/
sister-corita-kent-did-her-art-for-nuns/.
Aaron Rose, "Sister Corita," in *Power Up:
Female Pop Art*, exh. cat. Kunsthalle Wien,
Vienna (Cologne, 2010), p.151.

www.corita.org

KIKI KOGELNIK
(1935–1997)

Born in Bleiburg, Austria, Kogelnik studied
at the Academy of Fine Arts in Vienna. She
visited New York in 1961 and settled there in
1962. Among her friends were Claes Olden-
burg and Roy Lichtenstein, and she visited
Andy Warhol's Factory. Retrospectives of
her work have been held at Kärtner Landes-
galerie, Klagenfurt, Austria (1989); the Öster-
reichische Galerie Belvedere (1997); Ham-
burger Kunstverein, Hamburg, (2012); and
Kunsthalle Krems, Austria (2013). Her work
gained much greater recognition following
the exhibitions *Power Up—Female Pop Art*
at the Kunsthalle Wien in Vienna (2010) and
*Seductive Subversion: Woman Pop Artists
1958–1968* at the Brooklyn Museum in New
York (2010). She produced and directed the
short film *CBGB* (1978), and was awarded
posthumously the Austrian Cross of Honor for
Science and Art (1998).

Thomas Miessgang, "Kiki Kogelnik," in *Power
Up: Female Pop Art*, exh. cat. Kunsthalle
Wien, Vienna (Cologne, 2010), p.187.

www.kogelnikfoundation.org

YAYOI KUSAMA
(b. 1929)

Born in Matsumoto, Nagano Prefecture, Japan, Yayoi Kusama's faux autobiography, *Manhattan Suicide Addict*, recounts her New York years. She received a literature award for one of her novels, and is recognized today for her influence on fashion. She returned to Japan in 1973. She had four solo shows in France, New York, and Oxford, England in the 1980s. She participated in the 1993 Venice Biennale, and in 1994 began to receive numerous public sculpture commissions. From 1998 to 1999, a major retrospective traveled from LACMA to MoMA, the Walker Art Center, and the Museum of Contemporary Art, Tokyo. Her honors include France's Ordre des Arts et des Lettres in 2000, and from Japan, in 2006, a National Lifetime Achievement Award, the Order of the Rising Sun, and The Praemium Imperiale—Painting. All this for the child her mother said should never have been born.

"Yayoi Kusama with Midori Matsui" (interview), *Index Magazine*, 1998, http://www.indexmagazine.com/interviews/yayoi_kusama.shtml.
Grady Turner, "Yayoi Kusama," *Bomb 66* (Winter 1999).

www.yayoi-kusama.jp/e

ROY LICHTENSTEIN
(1923–1997)

Born in New York, Lichtenstein began painting classes at sixteen. His college art studies were interrupted by conscription. After armistice he stayed on in Paris studying French, and visited Picasso's studio, but was too shy to ring the doorbell. He completed his master's in art at Ohio State University and joined the faculty, before taking up a post at Rutgers University in New Jersey (1960), where Allan Kaprow was an inspiring and supportive colleague. Kaprow introduced Lichtenstein to Leo Castelli, and beginning with his 1962 exhibition at Castelli's his career progressed steadily. In 1969, his first retrospective opened at the Guggenheim Museum in New York before touring to other American museums. The Guggenheim held a second retrospective in 1994. In 1995, Lichtenstein added the National Medal of Arts to his honorary doctorates and art awards. A major retrospective traveled throughout the US and Europe during 2012–13.

Janis Hendrickson, "The Pictures That Lichtenstein made Famous, or The Pictures that Made Lichtenstein Famous," in *Roy Lichtenstein* (Cologne, 1993), p. 29.
Susan Goldman Rubin, *Whaam!: The Art and Life of Roy Lichtenstein* (New York, 2008).

MARISOL
(b. 1930)

Born in Paris to wealthy Venezuelan parents, Marisol's childhood was peripatetic. When her mother died, Marisol went to boarding school on Long Island, aged eleven. From then until her late twenties, she barely spoke, and performed painful penances. In her art training, she found Hans Hofmann's teaching most influential. After moving to New York in 1950, she befriended Willem de Kooning and other Abstract Expressionists. After her solo debut at Leo Castelli Gallery in 1958, she was seen as a Pop Art pioneer and featured in numerous key shows. She became an American citizen in 1963, but represented Venezuela in the 1968 Venice Biennale. Elected to the American Academy of Arts and Letters in 1978, she received the Premio Gabriela Mistral from the Organization of American States in 1997.

David Colman, "The Mask Behind the Face," *New York Times*, September 9, 2007.
Eleanor Heartney, "Marisol: A Sculptor of Modern Life," in *Marisol*, exh. cat. Neuberger Museum of Art (Purchase, 2001).

CLAES OLDENBURG
(b. 1929)

Oldenburg was born in Stockholm, Sweden. The son of the Swedish consul in Chicago, Oldenburg studied at Yale and the School of the Art Institute of Chicago before settling in New York in 1956. He met Jim Dine in 1956 and Allan Kaprow in 1958. He participated in Kaprow's happenings, and soon staged his own among his innovative sculptures in *The Street* and *The Store*, which helped define the mundane sensibility of Pop and brought recognition to his work. He was included in the Venice Biennales of 1964 and 1968. He had solo shows at the Moderna Museet (1966) and MoMA (1969), and his Guggenheim retrospective (1995) traveled internationally. In 2002 he received the National Medal of Arts. He has received numerous awards individually and with his partner, Coosje Van Bruggen.

Patty Mucha, "Soft Sculpture Sunshine," in *Seductive Subversion: Women Pop Artists, 1958–1968*, exh. cat. Rosenwald-Wolf Gallery, Philadelphia (New York and London, 2010), p. 148.

EDUARDO PAOLOZZI
(1924–2005)

Born in Edinburgh, Paolozzi's 1947 collage *I was a Rich Man's Plaything* is hailed as the first work of Pop Art. He founded the Independent Group (IG) in London in 1952, which pioneered Pop Art in Britain. Paolozzi studied at Edinburgh College of Art (1944), St. Martin's School of Art, and The Slade School (1945), before moving to Paris in 1947, where he met Tzara, Arp, Braque, Léger, Dubuffet, and other European artists. In 1952, he exhibited in the Venice Biennale. He co-curated *Parallel of Life and Art* (1953) and was included in *This is Tomorrow* (1956), both influential IG exhibitions. In New York, he exhibited at Betty Parsons Gallery (1960) and MoMA (1964). He taught at several German institutions, UCLA, and the Royal College of Art, London. Retrospectives of his work were shown at the Tate (1971) and in Berlin (1974). He received several honorary doctorates and was knighted by Queen Elizabeth II in 1988.

Robin Spencer (ed.), *Eduardo Paolozzi: writings and interviews*. Oxford: Oxford University Press, 2000.

MEL RAMOS
(b. 1935)

Ramos was born and raised in Sacramento, California, and studied at Sacramento State College (BA, MA, 1958). He is professor emeritus at California State University, East Bay, where he taught from 1966 to 1997. Recognized as a Pop artist for his early paintings of cartoon characters, such as *The Trickster* (1962), painted in impasto technique influenced by his mentor Wayne Thiebaud, Ramos's interest in sexy comic queens led to his focus on nudes like those in commercial pinups, which, beginning in 1965, he combined with commodities. His landmark exhibitions include a solo show at the San Francisco Museum of Art (1967), retrospectives at the Museum Haus Lange, Krefeld (1975) and the Oakland Museum in California (1977), a survey at the Rose Art Museum, Brandeis University (1980), and a traveling retrospective in Germany and Austria (1994–95).

Ken Johnson, "The Image Is Erotic. But Is It Art?," *New York Times*, January 20, 2009.

ROBERT RAUSCHENBERG
(1925–2008)

Born Milton Ernest Rauschenberg in Port Arthur, Texas, Rauschenberg studied art at the Kansas Art Institute, the Académie Julian in Paris, at Black Mountain College, North Carolina under Josef Albers (1948), and at the Art Students League in New York (1949–52). First noticed for the conceptual break-throughs in his work during the 1950s, he was the first American ever to win the inter-national prize for painting at the Venice Bien-nale (1964), and two 1964 retrospectives—at the Whitechapel Gallery, London, and the Jewish Museum, New York—widened appre-ciation of his work. He has received the National Medal of Arts (1993), a Grammy Award for his album design of the Talking Heads album *Speaking in Tongues* (1983), and the Outstanding Learning Disabled Achiever Award from Nancy Reagan (1985). Fame never mattered to Rauschenberg; a passionate phi-lanthropist, he believed that art can change the world. His foundation continues his mis-sion.

Robert Hughes, *The Shock of the New* (London, 1972).
Judith Mackrell, "The Joy of Sets," *The Guardian*, June 6, 2005.
Robert Rauschenberg, a Retrospective, ed. Walter Hopps et al., exh. cat. Guggenheim Museum (New York, 1997).
Robert Rauschenberg: Prints 1948/1970, ed. Edward A. Foster, exh. cat. Minneapolis Institute of Arts (Minneapolis, 1970).
Robert Rauschenberg, Branden Wayne Joseph, and Leo Steinberg, *Robert Rauschen-berg* (Cambridge, Mass., 2002).

JAMES ROSENQUIST
(b. 1933)

Born in Grand Forks, North Dakota, Rosen-quist's family settled in Minneapolis in 1942. An Art Students League scholarship brought him to New York at the age of twenty-one, where he studied under George Grosz, and he then became a signpainter. His billboard paintings graced window displays for Bonwit Teller and Bloomingdale's in the winter of 1959–60. In 1960, he quit his job and set up studio in Coenties Slip; artist neighbors included Robert Rauschenberg, Jasper Johns, and Robert Indiana. Following his sellout solo debut at Green Gallery in early 1962, he was included in important 1963 shows at MoMA and the Guggenheim, and commissioned to paint a mural for the 1964 New York World's Fair. After the success of *F-111*, the National Gallery of Canada, Ottawa mounted a retro-spective of Rosenquist's work in 1968. Since then, Rosenquist has been hailed as a key Pop artist, and his sixty-year career is still flour-ishing today. His 1992 *Time Dust* is thought to be the world's largest print, at seven by thirty-five feet.

Thomas Krens, Preface to *James Rosenquist: A Retrospective*, exh. cat. Menil Collection, Houston et al. (New York, 2003).
Lucy R. Lippard, "James Rosenquist: Aspects of a Multiple Art," *Artforum* 4, no. 4 (Decem-ber 1965).
Marco Livingstone, "James Rosenquist," in *The Dictionary of Art*, vol. 27 (New York, 1996).
James Rosenquist, quoted in Gene Swenson, "What is Pop Art? Part II," *Art News* 62, no. 10 (February 1964).

http://www.jimrosenquist-artist.com

MARTHA ROSLER
(b. 1943)

Born in Brooklyn, New York, Martha Rosler was educated at Brooklyn College (1965) and the University of California, San Diego. She works in many media, including video, photo-text, installation, and performance. An influ-ential critic and teacher, she taught at Rut-gers University in New Jersey for thirty years. She advises the education departments of the Whitney Museum and MoMA. Her photomon-tages addressed the domestication of women and the Vietnam War and, recently, her out-rage over America's wars in Iraq and Afghani-stan, which she views as the result of similar mistakes. In the 1980s her work focused on homelessness. A major retrospective of her work was shown in New York and in five Euro-pean cities (1998–2000). She has appeared in several international biennials and exhibi-tions.

Martha Rosler, "The Figure of the Artist, the Figure of the Woman (1983)" in *Seductive Subversion: Women Pop Artists, 1958–1968*, ed. Sid Sachs and Kalliopi Minioudaki, exh. cat. Rosenwald-Wolf Gallery, Philadelphia (New York and London, 2010), pp. 176–90.

ED RUSCHA
(b. 1937)

Born in Omaha, Nebraska, Ruscha was raised in Oklahoma City before moving to Los Angeles to attend the Chouinard Art Institute (1956). After his inclusion in *New Painting of Common Objects* at the Pasadena Art Museum (1962), he was rapidly assimilated into Pop Art circles, reinforced by his solo debut at Ferus Gallery in L.A. in 1963. In 1965 he became the designer for *Artforum* magazine, located above Ferus Gallery. His large public-art projects include murals in San Diego and Denver, and *Back of Hollywood* (1976–77), which was designed to be seen in the rearview mirror of a car driving by LACMA. Several Ruscha museum retrospectives have traveled internationally, including those arranged by the San Francisco Museum of Modern Art (1982), the Centre Georges Pompidou (1989), the Hirshhorn Museum and Sculpture Garden (2000), the Museo Nacional Centro de Arte Reina Sofía (2002), and the Whitney Museum of American Art (2004), and he has been the subject of numerous exhibitions in the US and abroad. LACMA—depicted in flames in Ruscha's famous painting—held a major exhibition of his work in 2012–13.

David Hickey, "Edward Ruscha: *Twentysix Gasoline Stations*, 1962—Photographer," *Artforum* 35, no. 5 (January 1997).
Edward Ruscha, interviewed by Christophe Cherix, January 24, 2012, The Museum of Modern Art Oral History Program.
Ed Ruscha, quoted in John Coplans, "Concerning 'Various Small Fires': Edward Ruscha Discusses His Perplexing Publications," *Artforum* 3, no. 5 (February 1965).

www.edruscha.com

LUCAS SAMARAS
(b. 1936)

Born in Kastoria, Greece, Samaras immigrated to New Jersey in 1948. He graduated from Rutgers University in 1959, did graduate work in art history with Meyer Schapiro at Columbia University, and studied acting at the Stella Adler Studio Theater. Associated with Rutgers artists Kaprow, Segal, and Lichtenstein, among others, he participated in Claes Oldenburg's and Kaprow's first happenings, and was in a rock band with Claes and Patti Oldenburg, Jasper Johns, La Monte Young, and Walter De Maria in the early sixties. Samaras is recognized for his inventiveness in a wide range of media throughout his career, most recently devoting himself to Photoshop-based art. His self is his most persistent subject, and he likes to keep himself to himself. He has had seven retrospectives and represented Greece at the 2009 Venice Biennale. He currently lives and works in Manhattan.

Kristine Stiles, ed., *Theories and Documents of Contemporary Art: A Sourcebook of Artists' Writings* (Berkeley, 1996).

GEORGE SEGAL
(1924–2000)

Educated at Rutgers University in New Jersey, the Pratt Institute of Design, and New York University, Segal lived on his family farm in South Brunswick, New Jersey, where he hosted art colleagues from New York and from the influential Rutgers University art department, many of whom he introduced to John Cage. Allan Kaprow invented the term *happening* at a gathering on Segal's farm in 1957. The Fluxus *Yam Fest* also took place there. He described himself as a Depression baby and had a keen empathy for ordinary, everyday working people. This is clear in many of his figures, seen engaged in everyday life. His figures are in more than sixty-five public collections. Segal received the National Medal of Arts in 1999. The Jewish Museum presented a retrospective of his work in 1998. He is the subject of two documentary films.

"Patronage II: The Western World since 1900," in *GLBTQ: An Encyclopedia of Gay, Lesbian, Bisexual, Transgender, & Queer Culture*, http://www.glbtq.com/arts/patronage_2,9.html.

MAY STEVENS
(b. 1924)

Born in Quincy, Massachusetts into a work-ing-class family, Stevens studied at the Mas-sachusetts College of Art, the Art Students League in New York, and the Académie Julian in Paris. Influenced by the poverty that sur-rounded her as a child, her involvement with the Civil Rights Movement led to her *Freedom Riders* exhibition in 1964, for which Martin Luther King, Jr. wrote the catalogue introduc-tion. She helped found the magazine *Her-esies: A Feminist Publication on Art and Poli-tics*, published from 1977 to 1992. She is the recipient of numerous awards, including a Women's Caucus for Art Lifetime Achieve-ment Award (1990), an Andy Warhol Founda-tion Award (2001), and a College Art Associa-tion Distinguished Artist Award for Lifetime Achievement "as an artist, poet, social activ-ist, and teacher."

Lucy R. Lippard, "May Stevens' Big Daddies," in *From the Center: Feminist Essays on Women's Art* (New York, 1976).
Cindy Nemser, "Interview with May Stevens," *The Feminist Art Journal* 3, no. 4 (Winter 1974/75), pp. 4–6.

MARJORIE STRIDER
(b. 1934)

Born in Guthrie, Oklahoma, Strider studied art at the Kansas City Art Institute in Missouri. A member of the New York avant-garde circle, she was friends with Roy Lichtenstein and the Oldenburgs. She made a plaster cast of Patty Oldenburg's breasts, later acquired by Sol Lewitt, and a chocolate version that was given to Claes Oldenburg. Strider had two solo exhi-bitions at Pace Gallery in New York, in 1965 and 1966, and participated in happenings organized by Allan Kaprow, Claus Oldenburg, and others. In 1969, she organized the first Street Work, a public art event. She concen-trated on soft sculpture during the seventies, and installed *Building Work* in 1976 at P.S. 1. From 1982 to 1985, a retrospective of her work toured the United States. She has received awards from the National Endow-ment for the Arts and the Pollock/Krasner Foundation (2009), and formed part of the acclaimed exhibition (and catalogue) *Seduc-tive Subversion: Women Pop Artists, 1958–1968*.

Amy Schlegel, interviewed by Meghna Chakrabarti and Anthony Brooks, "Women in Pop Art Subvert Stereotypes," Radio Boston, WBUR, March 28, 2011, http://radioboston. wbur.org/2011/03/28/women-pop-art.

WAYNE THIEBAUD
(b. 1920)

Born in Mesa, Arizona, Thiebaud was raised in Long Beach, California and Hurricane, Utah, where a family farm failed during the Depression. He worked as a cartoonist, designer, and advertising director (1938–49). He received his MA from Sacramento State College in 1952, where he began teaching in 1951 and from where he nominally retired in 1990. He produced eleven educational films, for which he won the Scholastic Art Prize (1961). He founded the cooperative Artists Contemporary Gallery, Sacramento. Thiebaud influenced a generation of students while teaching at the University of California, Davis during the 1960s and 1970s. He received the National Medal of Arts from President Clinton in 1994, and had an acclaimed retrospective at the Whitney in 2001.

Steven A. Nash, *Wayne Thiebaud: A Paintings Retrospective*. London: Thames & Hudson, 2000.

ANDY WARHOL
(1928–1987)

Born Andrew Warhola in Pittsburgh, Penn-
sylvania, in the 1950s Warhol became New
York's top commercial artist, but would
cross over into the avant-garde art world
and became a key figure in Pop Art. His
innovations extended to film, photography,
installation, packaging design, and rock
concert staging. His openly gay public per-
sona was the invented character of "Andy
Warhol," performed as if mimed behind a
mask, wearing an improbable silver wig.
He left others to speak for him and his work.
Warhol's Silver Factory was an epicenter of
sixties New York, where artists, rock stars,
celebrities, art patrons, transvestites, and
"alternative" and marginal social types
mixed—up until Warhol's attempted assas-
sination in 1968 caused him to be less public.
Since his death, recognition of his contribu-
tions has burgeoned through the world.

Victor Bockris, *The Life and Death of Andy
Warhol* (New York, 1989), p.144.
Steve Cox, "Andy Warhol: Killing Paper," Steve
Cox website, n.d., http://www.stevecox.com.
au/ANDY-WARHOL-KILLING-PAPA.
Ronnie Cutrone, quoted in John Timothy
O'Connor and Benjamin Lui, *Unseen Warhol*
(New York, 1996), p.61.
Grace Glueck, "Art Notes: Boom?," *New York
Times*, May 10, 1964.
Andy Warhol and Pat Hackett, *POPism:
The Warhol '60s* (New York, 1980), pp.33, 42.

The Warhol: Resources and Lessons,
edu.warhol.org.
www.warholfoundation.org

IDELLE WEBER
(b.1932)

Born in Chicago, Illinois, Weber was schooled
in Beverly Hills, California, and attended
Scripps College in Claremont (BA, 1954) and
UCLA (MA, 1956). She married attorney Julian
L.Weber in 1957. After her 1964 solo show
at Bertha Schaefer Gallery in New York, she
did not have another solo show until 1973, at
Hundred Acres Gallery. She has shown regu-
larly since then. Weber has taught art and
lectured occasionally throughout her career
and has served on several art and art-award
committees. During 1995, she was artist-in-
residence at Long Island University in New
York and in Australia at Melbourne University,
Victorian School of Arts. She has traveled
widely.

Charlotte S. Rubenstein, *American Women
Artists: From Early Indian Times to Present*.
Dresden (Tennessee): Avon Books, 1982.
Valerie Brooks, *"Artists Worth Watching:
Idelle Weber"* (M. D. Magazine 28, No. 2,
February, 1984).

TOM WESSELMANN
(1931–2004)

Born in Cincinnati, Ohio, Wesselmann was
educated at the Art Academy of Cincinnati and
the Cooper Union in New York, with the inten-
tion of becoming a cartoonist. Cofounded
Judson Gallery with Bud Scott and fellow
Cincinnati artists Marc Ratliff and Jim Dine.
Though Judson Gallery became a platform
for Dine, Claes Oldenburg, and Allan Kaprow,
Wesselmann debuted his *Great American
Nudes* at a solo show at Tanager Gallery—one
of several influential 10th-Street coopera-
tives—at Alex Katz's invitation. Following his
1962 solo show at the Green Gallery and
inclusion in the *New Realists* exhibition, he
became grouped with others in the nascent
Pop Art movement. The first retrospective of
Wesselmann's work was organized by the
Montreal Museum of Fine Arts in 2012, travel-
ing to the Virginia Museum of Fine Arts in
2013.

Wikipedia contributors, "Tom Wesselmann,"
Wikipedia, The Free Encyclopedia, http://
en.wikipedia.org//wiki/Tom_Wesselmann.

JOYCE WIELAND
(1931–1998)

Born in Toronto, Canada, as a child Wieland
turned to cartooning to cope with the death
of her parents. She worked in commercial art
and as an animator at Graphic Films, where
she met her husband, avant-garde filmmaker
Michael Snow. She had her first solo exhibi-
tion in 1960 at the Isaacs Gallery in Toronto.
In 1987, the Art Gallery of Ontario mounted a
major traveling retrospective of Wieland's
work, its first for a living Canadian female art-
ist, and she received the Toronto Arts Founda-
tion's Visual Arts Award. She was made an
Officer of the Order of Canada in 1982. Kay
Armatage produced a documentary about her
in 1987 entitled *Artist on Fire: Joyce Wieland*.
In her later years she suffered from Alz-
heimer's.

Vincent Johnson, "Yayoi Kusama's Hallucina-
tory and Hypnotic Monumental Art," *Fire-
side Chats* (blog), July 11, 2012, http://
fireplacechats.wordpress.com/author/
vincentjohnson1/page/9/.
Iris Nowell. *Joyce Wieland: A Life in Art*
(Toronto, 2001).
Sid Sachs, "Beyond the Surface," in *Seductive
Subversion: Women Pop Artists, 1958–1968*,
exh. cat. Rosenwald-Wolf Gallery, Philadel-
phia (New York and London, 2010).
Wikipedia contributors, "Joyce Wieland, "
Wikipedia, The Free Encyclopedia, http://en.
wikipedia.org/wiki/Joyce_Wieland.

PHOTO CREDITS

The illustrations in this publication have been kindly
provided by the museums, institutions and archives
mentioned in the captions, or taken from the publisher's
archives, with the exception of the following:
akg-images, Berlin: 25, 121; Martin C. Barry: 128 left;
The Bridgeman Art Library: 12, 14, 15, 16; © 2013. Albright
Knox Art Gallery/Art Resource, NY/Scala, Florence: 79;
The Bridgeman Art Library/Archivi Alinari, Firenze: 105;
bpk – Bildagentur für Kunst, Kultur und Geschichte: 63;
Rudolph Burckhardt: 81; © Sheldan C. Collins: 47; Devlin
Crow: 126 center; © Allan D'Arcangelo Archives, University
at Buffalo Anderson Gallery, State University of New York
at Buffalo: 122; 127 center; Davies: 138; © Foto-Sammlung
Jean Antoine: 126 left; GAB Archive/Redferns/Getty Images:
97; Courtesy of Gagosian Gallery: 12, 41; © The J. Paul
Getty Museum, Los Angeles: 119; © The Getty Research
Institute, Los Angeles/Vaughan Rachel: 135 center;
Michael Howell: 54; © Courtesy of Jann Haworth/Photo:
Ian MacMillan: 87; Kiki Kogelnik Foundation: 131 right;
Kippelboy: 129 left; Kunsthalle Tübingen: 31; Laurie
Lamprecht, New York: 132 center; © Jochen Littkemann,
Berlin: 101; © Photograph by Kerry Ryan McFate, courtesy
Pace Gallery: 89; Courtesy of marjoriestrider.com: 57;
© Jonathan Mills: 83; Montriveau: 129 center; The Montreal
Museum of Fine Arts, Christine Guest: 99; Ugo Mulas:
129 right; Ann Munchow, Aachen: 109; Courtesy Musée
d'Ixelles: 85; © The Museum of Modern Art, New York: 77;
The Museum of Modern Art, New York: 37, 45; © Courtesy:
the artist, and Galerie Nagel Draxler Berlin/Cologne:
91; Courtesy Norton Simon Museum, Pasadena, CA: 75;
© Photograph courtesy Pace Gallery: 128 center; Robert
Petersen: 134 left; © Mel Ramos: 117; Courtesy The
Rauschenberg Foundation: 29, 59, 73; Gary Regester: 135
left; © Corita Art Center, Immaculate Heart Community,
Los Angeles: 111; Rheinisches Bildarchiv Köln: 33, 35;
© Martha Rosler: 134 right; © Kevin Ryan. Kiki Kogelnik
Foundation, Vienna/New York: 51; © Courtesy of the artist
and RYAN LEE Gallery, New York: 103, 136 left; © BOB
SABIN: 107; See-ming Lee: 130 center; SilentMoment: 130
left; © Rudolf Springer: 127 right; © Photo courtesy of
Hollis Taggert Galleries, New York, by permission of the
artist: 13, 69, 137 center; © Tate Gallery, London 2013: 27,
113; © University of Lethbridge Art Gallery: 71; Vernisage-
fan: 133 right; © Julian Wasser: 93; © Joshua White: 131
center; © Whitney Museum of American Art, New York: 65

© Prestel Verlag, Munich · London · New York, 2013

© for the works reproduced is held by the artists,
their heirs or assigns, with the exception of:

Allan D'Arcangelo, Evelyne Axell, Jim Dine, Rosalyn Drexler,
Marcel Duchamp, Marisol Escobar, Richard Hamilton,
Robert Indiana, Jasper Johns, Roy Lichtenstein, Eduardo
Paolozzi, Mel Ramos, Robert Rauschenberg, James Rosen-
quist, George Segal, Wayne Thiebaud, McHale Voelcker,
Tom Wesselmann with © VG Bild-Kunst, Bonn 2013; Peter
Blake with © Apple Records; Derek Boshier with © Derek
Boshier; Chryssa with © Kappatos Gallery; David Hockney
with © David Hockney; Christa Dichgans with © Christa
Dichgans; Allan Kaprow with © Kaprow Estate; Sister
Corita Kent with © Corita Art Center, Immaculate Heart
Community, Los Angeles; Kiki Kogelnik with © Kiki Kogel-
nik Foundation; Yayoi Kusama © YAYOI KUSAMA; Claes
Oldenburg © Artist; Joyce; Vaughan Rachel with © Artists
Rights Society (ARS), New York; Marta Rosler with © www.
martharosler.net; Ed Ruscha with © Ed Ruscha. Courtesy
of the artist and Gagosian Gallery; Lucas Samaras with
© Lucas Samaras, courtesy Pace Gallery; May Stevens
with © Ryan Lee Gallery; Marjorie Strider with © Marjorie
Strider. http://marjoriestrider.com; Andy Warhol with
© 2013 The Andy Warhol Foundation for the Visual Arts,
Inc./Artists Rights Society (ARS), New York; Idelle Weber
with © Permission of the Artist; Joyce Wieland with
© National Gallery of Canada

Cover: Roy Lichtenstein, *Masterpiece*, see p. 43

Prestel Verlag, Munich
A member of Verlagsgruppe Random House GmbH

Prestel Verlag
Neumarkter Strasse 28
81673 Munich
Tel. +49 (0)89 4136-0
Fax +49 (0)89 4136-2335

Prestel Publishing Ltd.
14–17 Wells Street
London W1T 3PD
Tel. +44 (0)20 7323-5004
Fax +44 (0)20 7323-0271

Prestel Publishing
900 Broadway, Suite 603
New York, NY 10003
Tel. +1 (212) 995-2720
Fax +1 (212) 995-2733

www.prestel.com

Library of Congress Control Number: 2013945737; British
Library Cataloguing-in-Publication Data: a catalogue record
for this book is available from the British Library; Deutsche
Nationalbibliothek holds a record of this publication in the
Deutsche Nationalbibliografie; detailed bibliographical data
can be found at: http://www.dnb.de

*Prestel books are available worldwide. Please contact your
nearest bookseller or one of the above addresses for infor-
mation concerning your local distributor.*

Editorial direction: Claudia Stäuble
Project management: Julie Kiefer
Picture editor: Thorsten Schmidt
Copyedited by: Jonathan Fox
Layout: Vornehm Mediengestaltung GmbH, Munich
Design & production: René Fink
Separations: Reproline Mediateam, Munich
Printing and binding: Druckerei Uhl, Radolfzell

Verlagsgruppe Random House FSC® N001967
The FSC®-certified paper Hello Fat Matt
was supplied by Deutsche Papier.

ISBN 978-3-7913-4845-2